PRESENCE

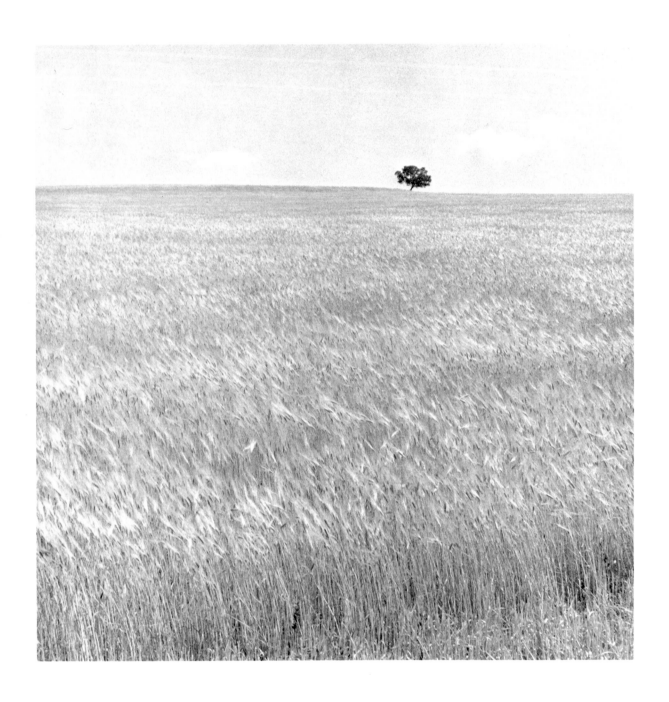

PRESENCE

PHOTOGRAPHS WITH
OBSERVATIONS BY
SHIRLEY C. BURDEN

PREFACE BY
THOMAS KEATING

AN APERTURE BOOK

A seed
needs good earth
for its roots
and water
for growth.
A photographer,
inspiration.

My debt is to
Robert Frank
Michael Hoffman
Dorothea Lange
Edward Steichen
John Szarkowski
Todd Walker
Minor White

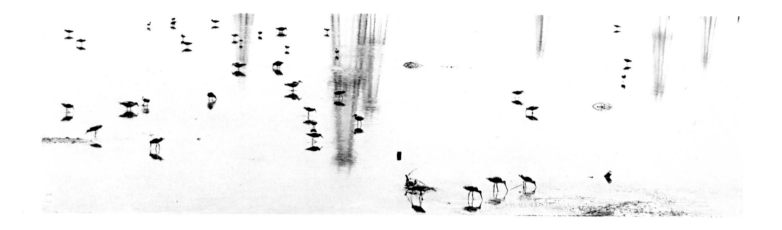

CONTENTS

Preface

What is presence? It is a relationship to something or to someone.

Shirley Burden's sensitive presence to concrete things is recorded in these photographs and in his commentary. He details patterns on a street in Los Angeles and discovers humorous groupings of chairs in a French park. A dead pigeon epitomizes the fruit of his search through the abandoned buildings of Ellis Island. He reveals a special presence to people like Dorothea Lange and the pilgrims at Lourdes—and they reveal theirs to him. He is also present to the invisible world of faith through his experience at the Abbey of Our Lady of Gethsemani and at Lourdes, where the past, present, and future seem to come together for him in the realization of a Presence that is beyond all words and photographs—yet is nonetheless somehow present in them.

I belong to the same order as the Abbey of Gethsemani. Since 1960, when Burden visited the abbey and worked with Thomas Merton on *God Is My Life,* a number of changes have taken place in the order and in its way of life. Monks no longer cut their hair in the shape of a crown, the beautiful Latin Gregorian chants have been translated into English, and the strict silence that Shirley Burden describes has been significantly modified. There is now a balance between silence and speech and between solitude and openness to the world. Somehow, every human being, even a monk, grows best in confrontation with these opposites. Yet in the monasteries of the order the traditional search for God remains intact. In fact, it is becoming more vigorous because the essentials, through the sifting of recent years, are emerging into clearer focus.

When I joined the order, the life of a Trappist monk was my ideal. It mobilized my youthful energies, lured me into the unknown, and stabilized my direction. But I was often unhappy because I could not measure up to my ideal. I was eager to do things for God, to be very austere, to guide others along the monastic path, to be a great contemplative—efforts that wasted as much good energy as living in an uninsulated house at the North Pole. At the same time, the return to fundamentals at the heart of monastic life has led me to appreciate the universal vocation of every man and woman:

to be a human being. That vocation is a pure gift. Because it is what I already am, I am content. Consequently, I find myself less interested in the ideal to be achieved and more concerned about where to begin. I keep pushing my starting point farther back, while the ideal disappears into the distance. Attainment is not my business anyway, but God's. My business is to keep going, which means to start over again and again—but without distress at being always at the beginning. Perhaps the reason my perspective has changed is that I am learning that presence is more important than accomplishment. God is present to everything, just as the eye of a camera sees everything the way it is. But God's eye also penetrates to the heart of man and to the heart of woman. Nothing is unrecorded. Yet we in our turn may not be present to God. Like the subjects of a photograph, we may not perceive that Someone sees a marvelous value and beauty in us and is taking our picture.

We are summoned into the presence of God by the fact of our birth, but we become present to Him only by consent. As our human faculties gradually develop and unfold, the capacity to enter into a relationship with God increases, but each new depth of presence requires a new consent. Each new awakening to God changes our relationship to ourselves and to everyone else, as well as to Him. Growth in faith is growth in the perception of all reality.

What is faith? It is a special kind of presence. It focuses on *who* is present and *how*. The light of faith may resemble the rays of the sun filtering through a stained-glass window and illuminating the various tints and delicate intricacies of the glass, as well as its cracks and flaws. Thus, faith filters through our human faculties manifesting, along with the evidence of human frailty, the beauty and goodness of our personhood by the quality of the thoughts and actions that it inspires.

Faith can also resemble the rays of the sun pouring through a transparent glass window, an experience of light that is much more powerful. At times the glass seems itself to be transformed into light. Thus, surrender to faith leads to a more intimate relationship

with God—even to a kind of identification that deepens the experience of presence, giving it a wholly new meaning and perspective.

But there is a further possibility. Suppose that somehow the glass is shattered, leaving in place of the window a great open hole. Presence would no longer be a relationship between two parts, but a oneness. Such is the ultimate destiny of human presence. Love is what changes the perception of ordinary reality into insight, and presence into unity. As love grows, therefore, so do insight and unity. Art seeks to assist this transformation by pointing to it or by expressing it. Everything depends on the artist's level of insight and openness to reality. Is the function of the art of photography to preserve the artist's moment of insight or simply to let reality speak for itself? Perhaps it is not for the photographer to reply, but to open himself and to present his lens to the light.

Thomas Keating
Abbot
Saint Joseph's Abbey
Spencer, Massachusetts

PRESENCE

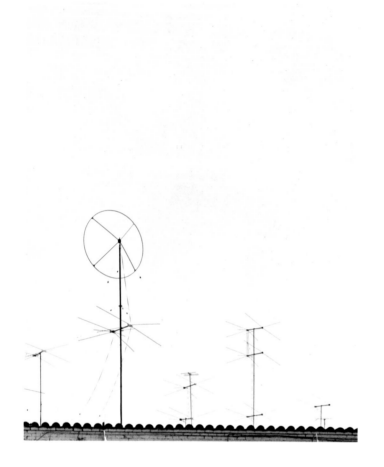

Patterns

Melrose Avenue is a not-so-exciting avenue in Los Angeles, California. It has stores, restaurants, printing establishments, offices, etc., etc., etc., and a small factory where they make plaster copies of famous sculptures such as Romulus and Remus and the wolf, with all the accessories. I should have known the avenue well: I traveled it daily on my way to work. All I usually saw was a few pedestrians who always got in the way, lots of cars with stupid drivers in front of me and behind, red lights that never turned green.

One day something happened. While waiting for the lights to change, I made a careful study of the beautiful blonde hooker in my rear-view mirror and the very old man in front of me with the triple cataract glasses. Then I glanced hopefully at the traffic light. There behind it on the roof of a low building were some television antennas. They reminded me of the structures that hold fireworks on the Fourth of July. The fireworks had had their moment of glory and the applause had ceased. Only the majestic skeletons remained delicately silhouetted against the early morning sky.

After that, I took a number of design shots, the best of which I showed to my idol, Edward Steichen, who was curator of the photography department at The Museum of Modern Art in New York. He looked at them with proper reverence and said he would like to exhibit them in his next show, "Diogenes with a Camera IV." That was the beginning of my photographic career.

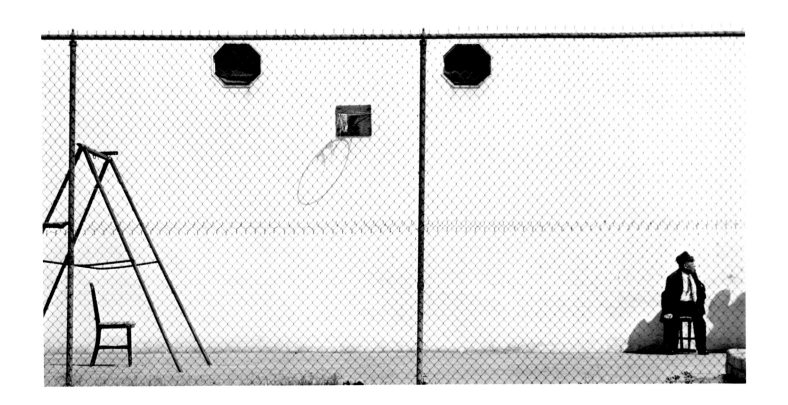

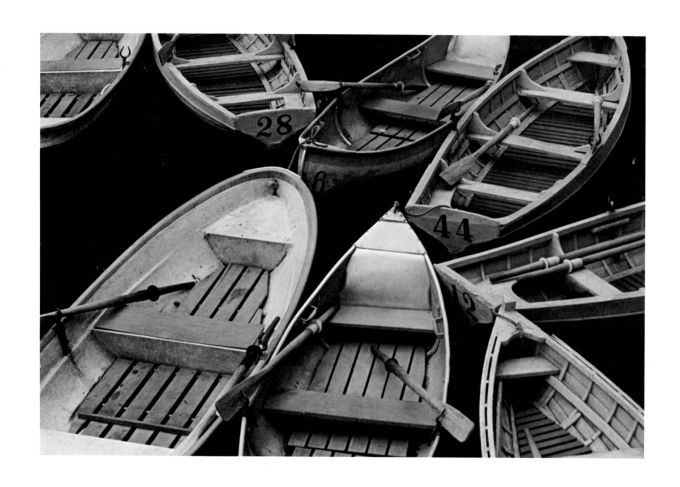

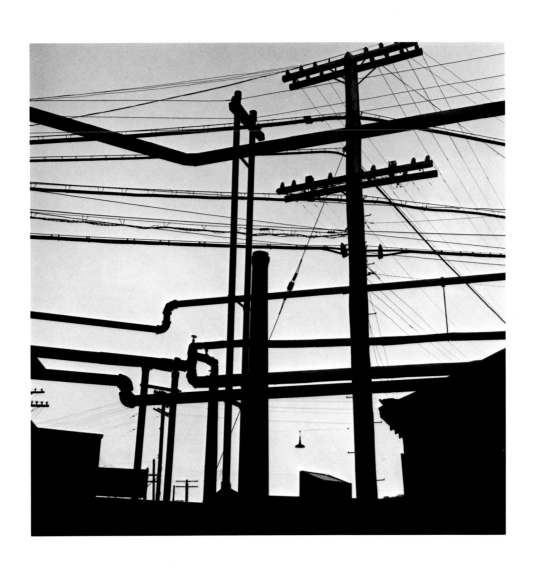

Possibly, that was why I went back many years later, after the bridges and tunnels had been built, to see how my Weehawken ferry was faring. It wasn't. There were still a few commuters, but that was about all.

By the time these pictures were taken, I realized I had been attending the rehearsal for a funeral that was soon to be. A short time afterward, all the Weehawken ferry buildings burned to the ground, and my ocean fantasy was terminated.

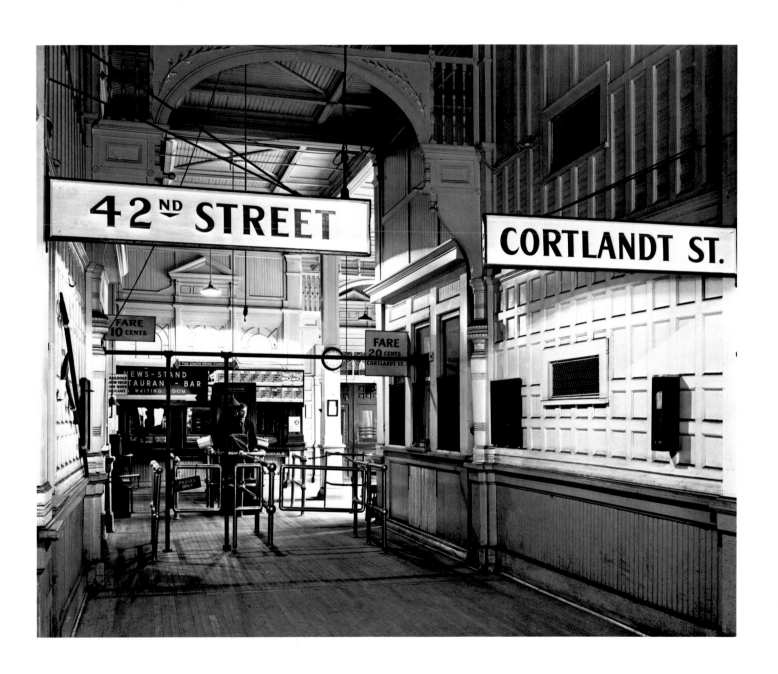

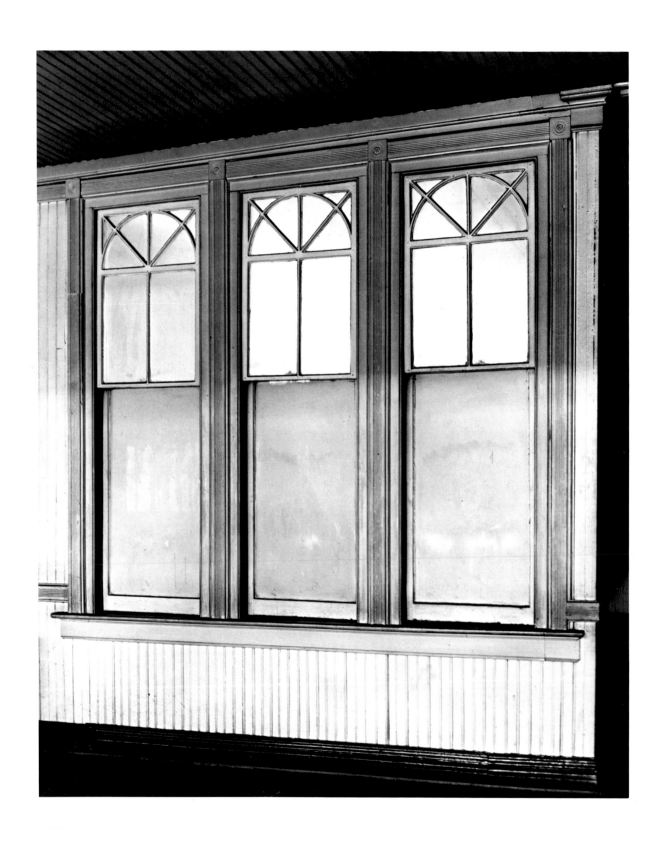

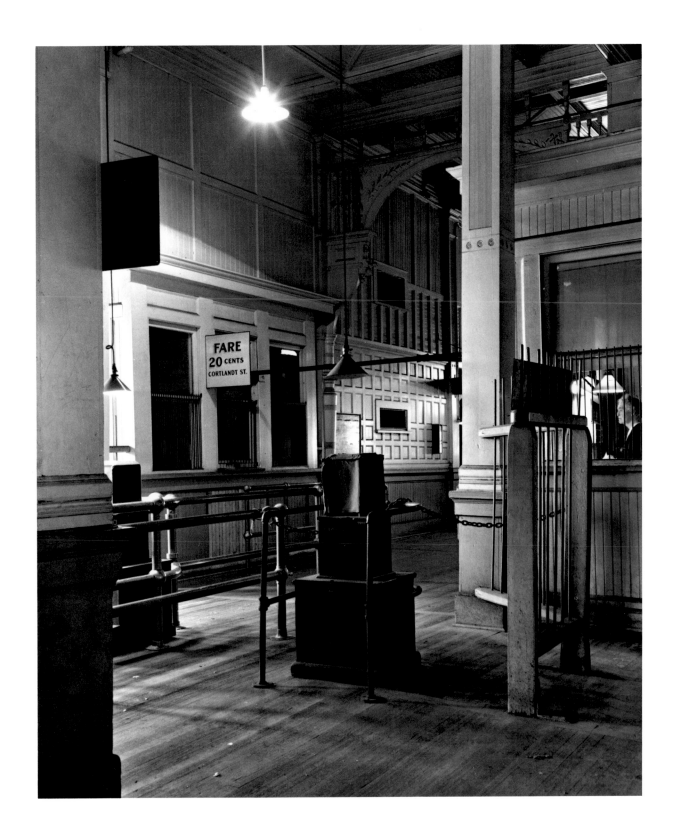

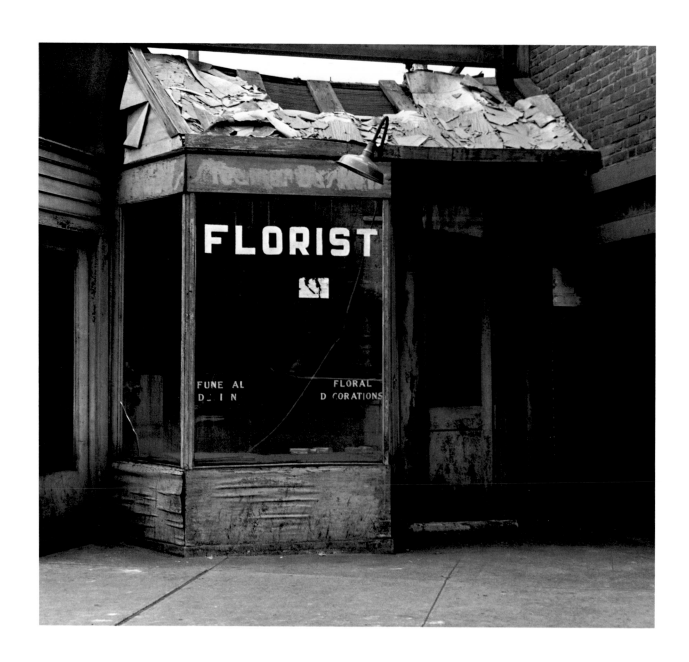

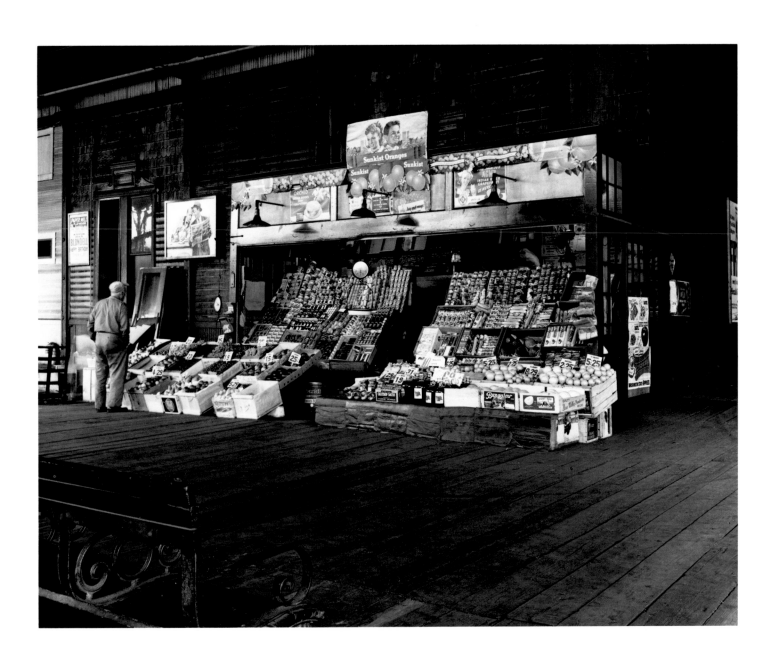

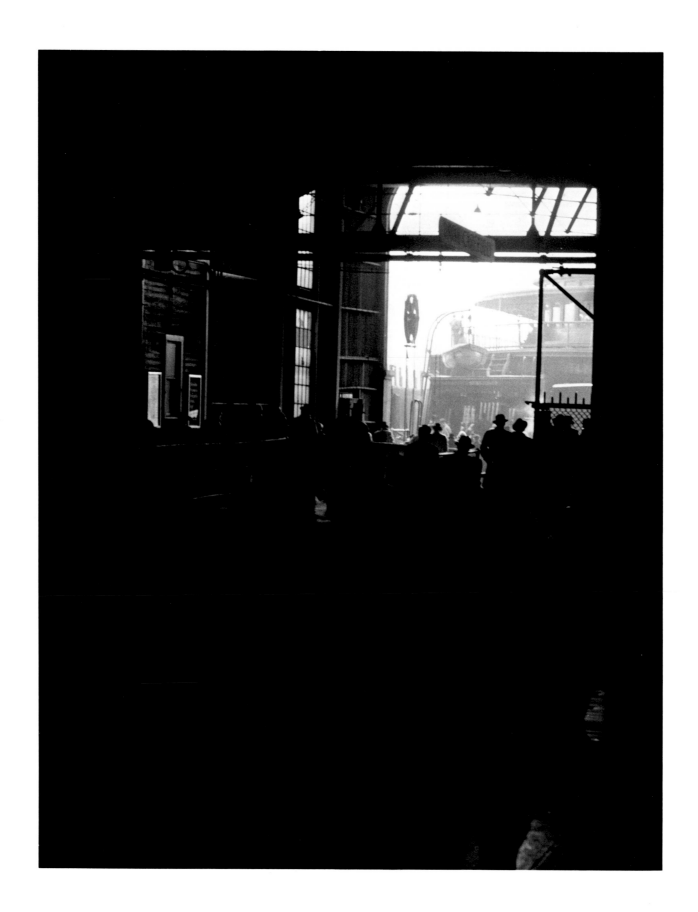

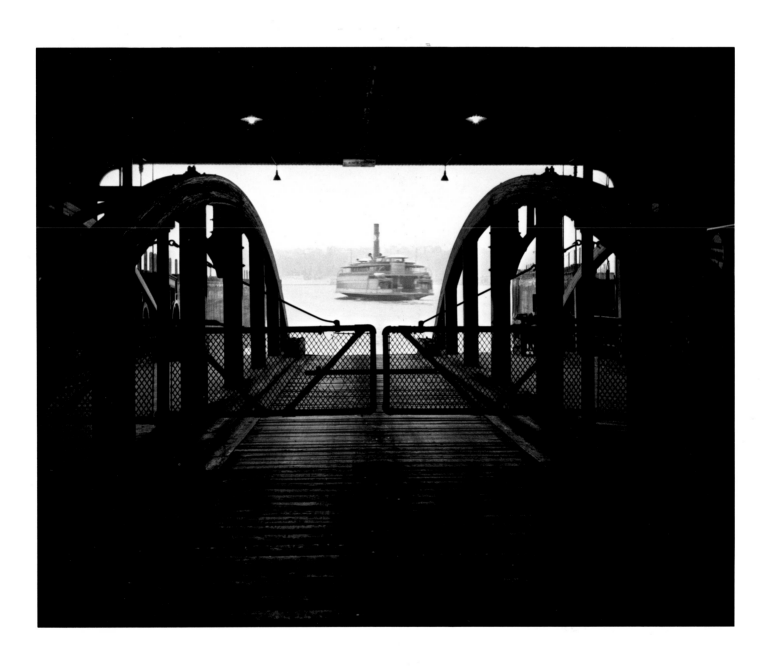

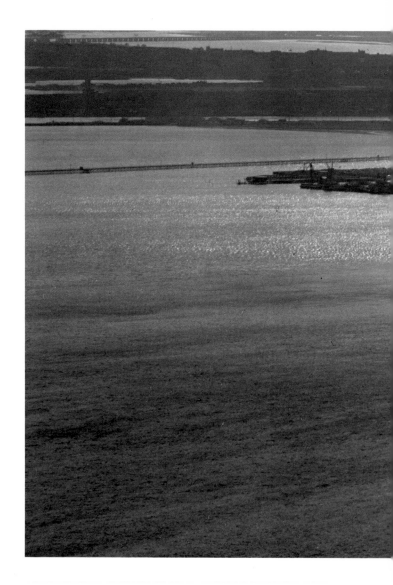

Ellis Island

I was born in New York City—lived there most of my life. Like many New Yorkers, I knew very little about my birthplace. I had only heard of Ellis Island, "The Gateway to America." It was an island in New York Harbor that people from other countries were obliged to visit before they were admitted to the United States.

At twenty, I went to Hollywood to seek fame and fortune in the motion-picture industry. From time to time, I would fly back to New York to visit my family. It was on one of these trips that Ellis Island entered my consciousness again. The cocktails had been exhausted, all the food eaten, the wine drunk, the movie slept through, and I was about to fascinate the lady next to me with witty conversation, when that one and only New York skyline came into view. Not far from the Statue of Liberty the setting sun outlined an island cloaked in blackness.

Several days went by before I decided to have a look at Ellis Island. I took the subway to The Battery, walked across Battery Park past the shell of the old aquarium, and stood at the water's edge. There it was, a pile of masonry, abandoned and forgotten. I was hooked. I had to have a closer look. But, how to get there?

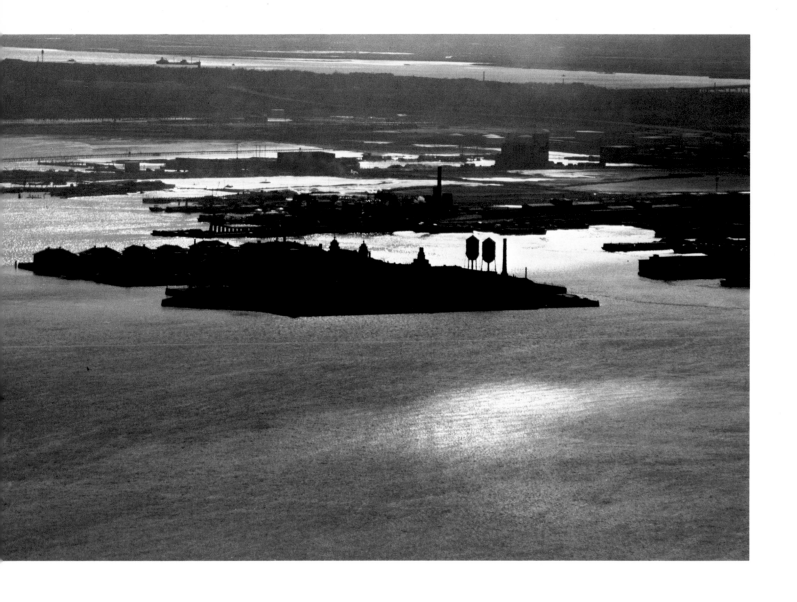

I started walking up the West Side Highway past the docks, looking for a friendly boatman. My first encounter was with a policeman who was coiling rope on the stern of a police patrol boat. After the customary conversation about the weather and life in general, I told him I wanted to go to Ellis Island and take some pictures—would he drop me off sometime when he was patrolling the harbor? He said he couldn't, and asked whether I had permission to go there. That terminated the conversation rather abruptly.

My next stop was the immigration office at Columbus Circle. The office looked very much like a post office: lots of small windows with bored, uninterested faces looking out at long lines of frustrated people. At the last window there was a white-haired motherly type. The line was longer than the others, but I had a hunch she would be worth waiting for.

Once again, I told my story. The unexpected question confused and bothered her, but bureaucracy hadn't taken over completely. She hesitated. Official permission might be impossible, but if I could find a way of getting there, I might not have too much trouble when I arrived.

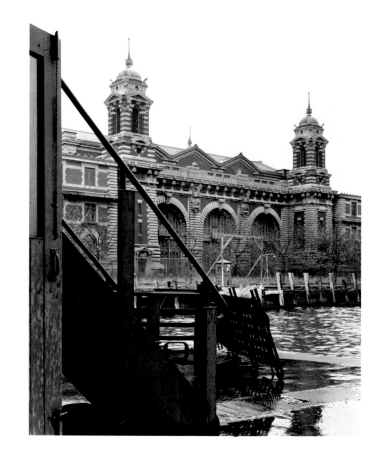

Next day I took the subway to Wall Street, walked over to the East River, and started my search. I walked and walked and walked, studying every boat as a possible means of transportation. I was about to give up when I saw a scow. Webster's dictionary has it: "A scow is a large boat with a flat bottom and square ends, chiefly used for freight and usually towed." My scow was not large, and it was not towed, although many times during our lengthy crossing I wished it had been. Somewhere, within its depths, there was a motor that propelled it, if you don't mind using "motor" and "propelled" loosely. On its deck was an object that looked like a telephone booth. Inside, a man, all 300 pounds of him, was sipping coffee.

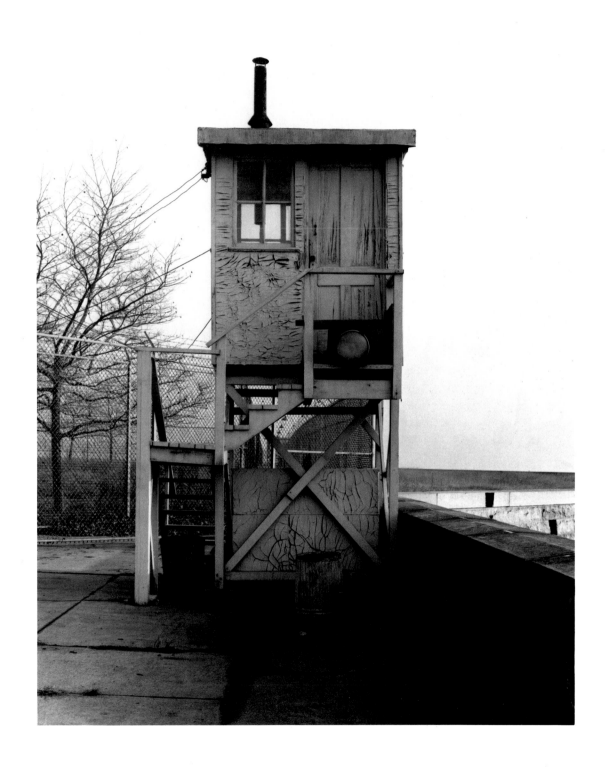

Maneuvering myself down a very slippery ladder and across an equally slippery deck, I knocked on the booth door. The man opened it a crack—I don't think he dared open it more, or he would have flowed onto the deck—and asked what I wanted. Would he take me to Ellis Island? The look in his eye told me he would do anything for money. Before discussing it, further conversation was in order.

He offered me coffee, which was most welcome, since it was very cold and there was no room for me in the booth. I learned he earned his living by selling produce to the boats anchored in the harbor. After I had finished my coffee, I thought it was time for a business talk. How much to take me to Ellis Island? "Fifty bucks," he replied. I have never been much of a bargainer, but somehow I felt the time had come for me to have a try. We talked about hard times, how much everything cost, how bad business was, and then settled on twenty dollars for the trip. It was a decision I was later to regret.

The great day finally arrived. There wasn't any smog: they didn't have smog in those days. There wasn't any pollution either. A slightly tired head of lettuce, floating in the harbor, was a thing of beauty rather than something to have a Congressional investigation about. The sky was very blue, the sun very bright. It was crisp and cold. Even six o'clock in the morning didn't seem too early to start.

On any ordinary craft the trip to Ellis Island would take about ten minutes. We were still plowing through the waves a half hour after leaving the dock. This was the time it was worth being aboard the tortoise rather than the hare. If you haven't seen the New York skyline from a boat early in the morning, you haven't lived.

We finally arrived at the island and tied alongside the ferryboat *Ellis Island.* There was no one in sight. The lapping of the waves against the hull of the ferryboat was the only sound. The buildings stood there looking down at me as if to ask why I was disturbing their solitude.

It was some minutes before I turned to see what had happened to my boat. The deckhand had cast off. The boat was clear of the slip and about to take off for parts unknown. The captain opened the door of his "phone booth" and yelled at me. "I can't pick you up. I'm too busy." True, I had saved thirty dollars on the deal, but was it worth it? My friend at the immigration office had said she thought there was a caretaker on the island. I prayed she was right.

I started walking, where to I didn't know. At first, the pictures I saw were beautiful, then they grew sad. There was no guard, no baby's cry, no whispers of hope, no longing for liberty, just a mute skeleton of the past. Those tall skyscrapers just across the bay must be an illusion. I was on another planet.

In the distance I could hear a humming sound. Was it a flying saucer warming up or dynamos in a powerhouse? The latter proved to be correct. I met Mr. Jones there. He was neither a ghost nor a man from outer space. He was large, powerful, black, and superintendent of the island. I introduced myself, told him my story, and explained what I wanted to do. Mr. Jones, I soon found

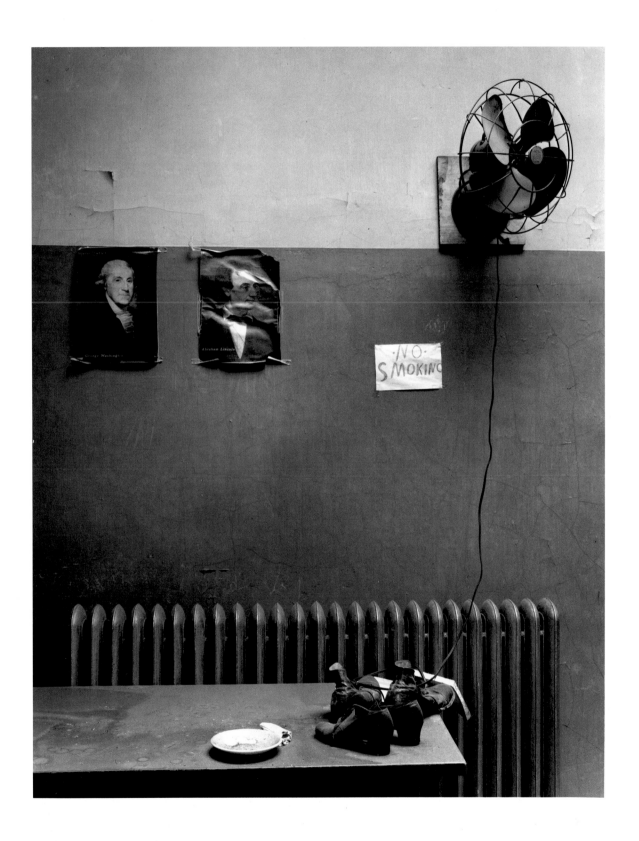

out, had many attributes besides his physique. He was soft-spoken, a wonderful storyteller, and best of all, he accepted me at face value.

The next two days we spent together, rediscovering the island. Mr. Jones knew his subject well. Each building, each room we entered came alive with his stories. Mr. Jones was a storyteller rather than a statistician, so I had to do some research to find out the following:

Ellis Island is a man-made island. It is twenty-seven and a half acres in size, and the dirt that forms it was ballast from foreign ships entering the harbor. There are thirty-five brick buildings and one greenhouse now on the island—all in very bad condition.

It has had many names: In 1630, Gull Island; in 1661, Oyster Island; in 1730, Bucking Island; and in 1765, Gilbert Island. Later, when it was used as an immigration station, the immigrants who were not allowed to enter the United States called it "The Isle of Tears."

Many people have owned it: The Mohegan Indians in 1630, Mynher Paw in 1661, Captain William Dyre in 1674, Thomas Lloyd in 1686, and Samuel Ellis in 1780. More recently, New York State and the federal government have both owned it. It wasn't always used as an immigration station. In 1757 it was a pest house. In 1765 pirates were hanged there. In 1780 it was a tavern, in 1808 a fortress, and in 1892 it became an immigration station. It has also been a prison and a hospital.

For the fourteen million immigrants who passed through Ellis Island, it was truly "The Gateway to America."

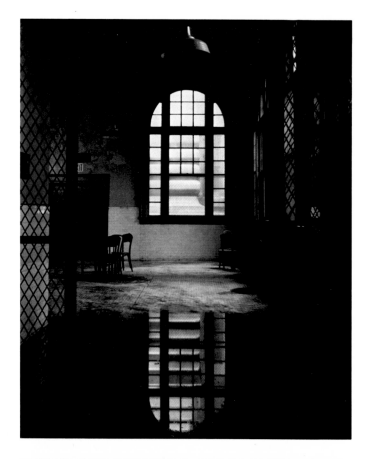

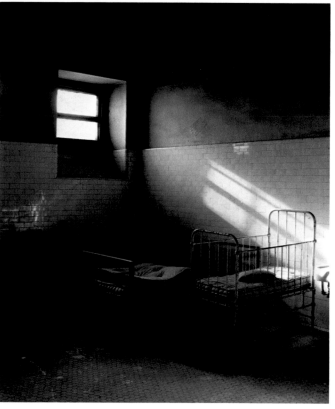

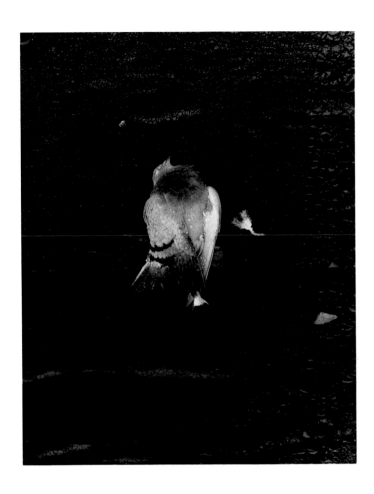

The days flew by. Each morning we would meet at a dock next to the Staten Island Ferry slip in Manhattan. The Coast Guard would pick us up, take us to the island, and bring us back each evening. It was far more luxurious than my first trip on the scow.

We met in the powerhouse for lunch. Mr. Jones's Scandinavian assistant had a way with a skillet and a can of Sterno that would make a French chef blush.

During the day I had the island to myself. Sometimes, I would take pictures. Sometimes, I would look at the brick walls and wonder what they could tell me about the people they had seen and heard.

I took many pictures of Ellis Island: some worked, some didn't. I was always looking for that one shot that would say everything. So far, I hadn't found it.

It was late in the afternoon. The rain had been coming down in buckets all day. The light, when there was any, was flat. It just wasn't my day. I started down the fire escape with my equipment. All I could see below was acres of rain-drenched black asphalt roofs. Then a white object caught my eye. It was a dead pigeon. Somehow, it summed up everything I felt about the island—a lonely, desolate, decaying piece of the past.

Not far away, the Statue of Liberty holds her torch high on Bedloes Island, renamed Liberty Island. At her feet they built an immigration museum. Meanwhile, Ellis Island, "The Gateway to America" in 1892, has started to have guided tours. You can get there now on a ferryboat instead of a scow.

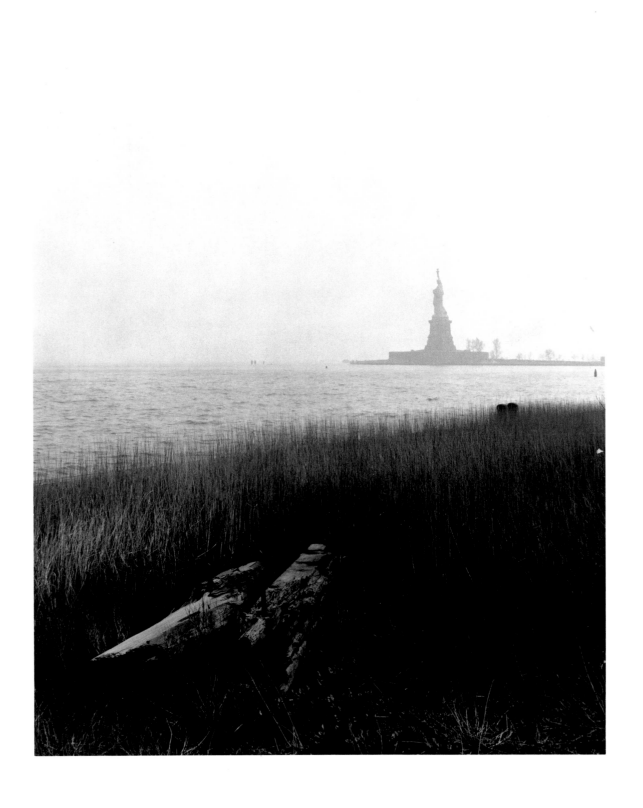

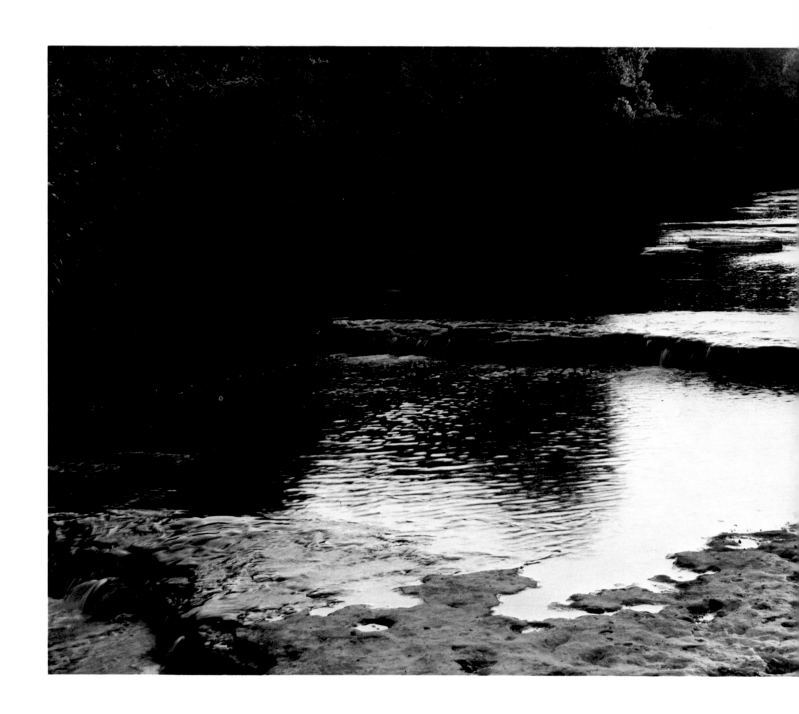

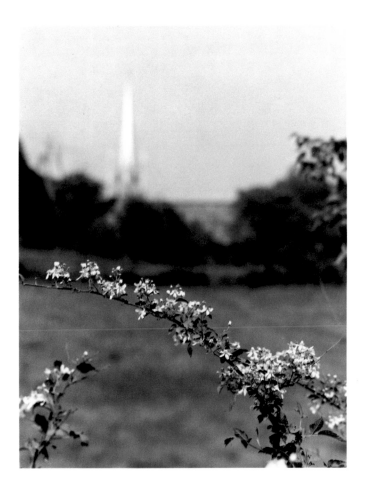

What Is Faith?

It is belief, without need of certain proof. Science has the faith that it can solve any problem if given the time. This satisfies man because he reasons it can't be unless he can see, feel, smell, or understand it.

Religious faith, on the other hand, is something different: you can't see it; you can't feel it, you can't smell it, and often you don't understand it. But if you have faith, all this doesn't matter.

That's a pretty hard premise to accept. I have been exposed twice to this type of faith: once at a Trappist monastery near Louisville, Kentucky—a cloistered order where talk is prohibited; the other at Lourdes in France, where the Virgin Mary appeared to a young girl called Bernadette.

When Edward Steichen asked if I would be interested in photographing a Trappist monastery in Kentucky, I worried more about whether or not I could do it than I did about faith. On the plane to Louisville I wondered what use a group of men holed up in a monastery, dedicated to silence and prayer, were to mankind. They ran a farm and sold hams and cheese at Christmas in order to survive, but that didn't do much for their neighbor.

The country around Our Lady of Gethsemani was beautiful and peaceful. My first view of the monastery was very romantic. The closer I got, the more it changed. The buildings were a conglomerate of styles. The rooms in the older buildings were very large, and the ceilings very high. The room I was assigned to had a bed, a straight-backed wooden chair, a table, and a tree to hang my clothes on. Down the hall there was a bathroom with all the necessary equipment, including shower heads that dripped, not in unison.

I'll never forget my first night at Gethsemani. It was hot and humid, and I was lonely. I had difficulty getting to sleep. All I could think of was, why had I left my comfortable home and my wonderful family to come here to do something I probably wouldn't be able to do anyway. I must have drifted off, because when I awoke, it was pitch black. It was still hot and very humid, and I had no idea where I was. I lay there trying to remember.

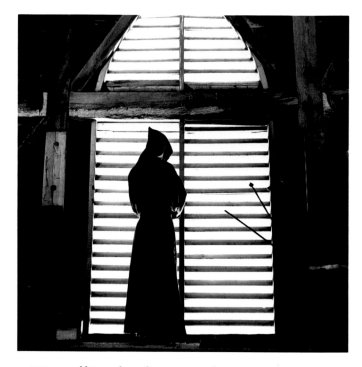

Way off in the distance there was music—the most beautiful singing I had ever heard. I decided it must be a dream. I got out of bed, found the door, and went out into the hall. The voices were a little closer now, and, oh, so beautiful. I stood for a while, listening, trying to figure out where they came from. As I walked down the hall, the voices seemed to envelop me. Light streamed from under a small door. I opened it slowly, and there before me was a church filled with men in white robes, singing their hearts out to God. That sight and sound will never leave me. An introduction like that, to a place I had reservations about, left me in a peculiar state of mind.

The following morning a monk, who was in charge of public relations for the monastery,

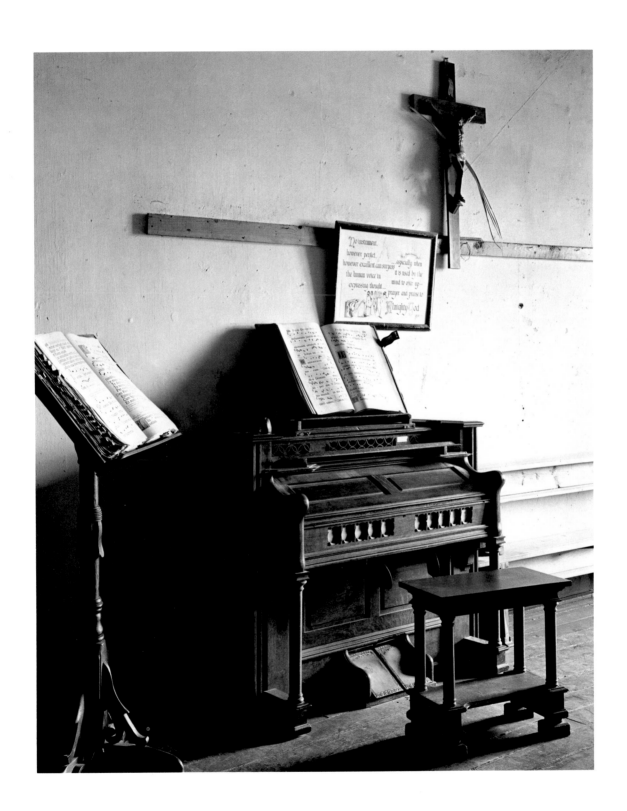

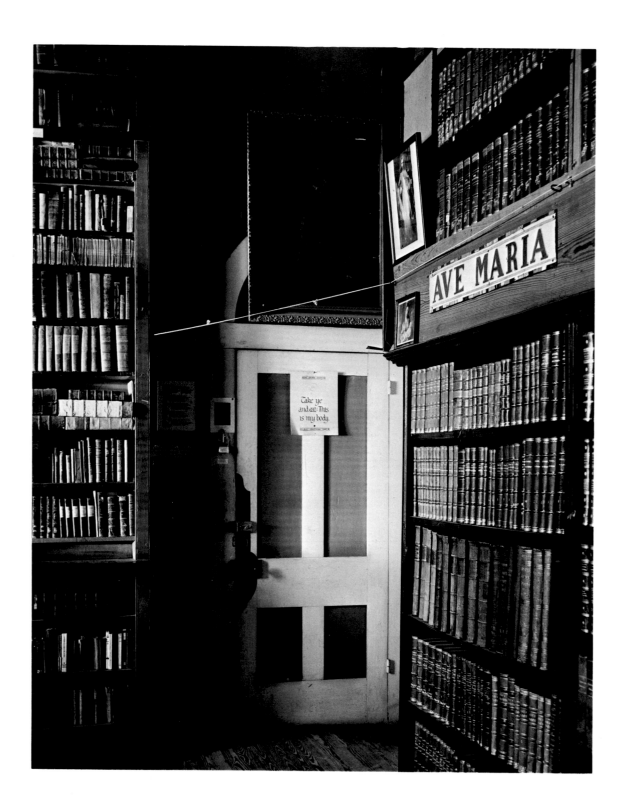

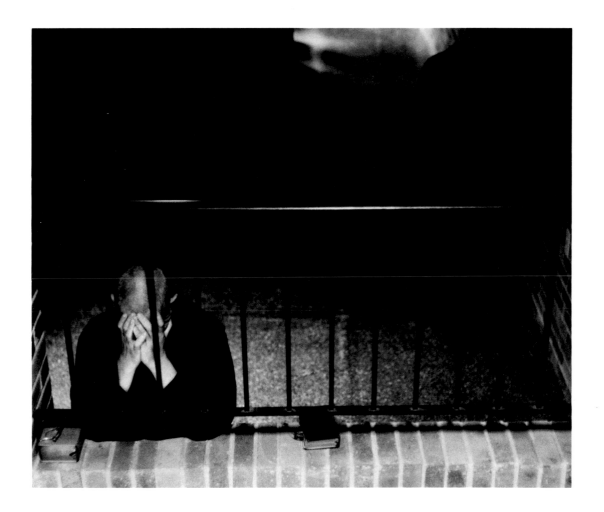

took me in tow and gave me a Cook's tour. The only trouble was that he told me exactly what pictures he wanted me to take. I said that if that was his plan he should hire a photographer from Louisville. He took the rebuke gracefully and stopped making suggestions. Only then did I realize what a predicament I was in. Just what was I going to photograph?

That evening I was walking in the fields near the monastery, wondering what my next move should be. Thomas Merton, author of the best-seller *The Seven Storey Mountain*, was a monk at Gethsemani at the time, the instructor of novices. Perhaps he would write the text for a book we might produce jointly.

I was lost in thought when two monks walked up to me and asked what I was doing there. I explained: I was planning a book of photographs on the life at Gethsemani. They smiled, and we talked awhile. One of the monks turned out to be the Father Abbot of the monastery, the other Thomas Merton.

At first, it was difficult getting to know the monks. Conversation was a necessity in my life. How could I get to know someone if I couldn't talk to him. The more I watched these people at their daily tasks and the more I photographed them, the more I felt conversation wasn't the only answer.

These men came from all walks of life: one had once been a jazz trumpeter with a hot

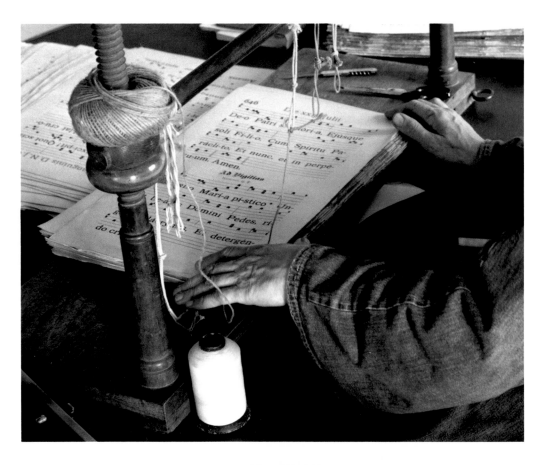

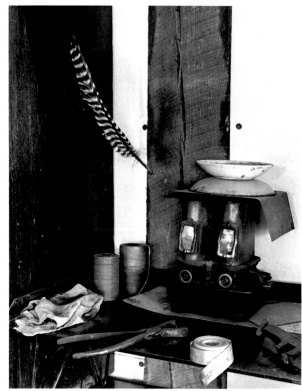

orchestra in Chicago; another had been a motion-picture director from Hollywood; and so on. They came to Gethsemani to get closer to God. Whether they attained their goal, only they and God knew. You could say I was brainwashed by the silence. Perhaps I was, but somehow I felt there was a close relationship between the pictures I took and those heavenly voices I had heard my first night there.

Father Merton agreed to write the text for my pictures. When I finished shooting, I sent him proof sheets of the results. Days—weeks— went by. Finally a letter arrived. "Dear Shirley," it read, "I think you know what to do with them better than I do. I will be only too happy to write the introduction." It took me a long time to recover from that letter. With the help of the Bible and a better understanding of what Gethsemani was all about, I completed *God Is My Life*.

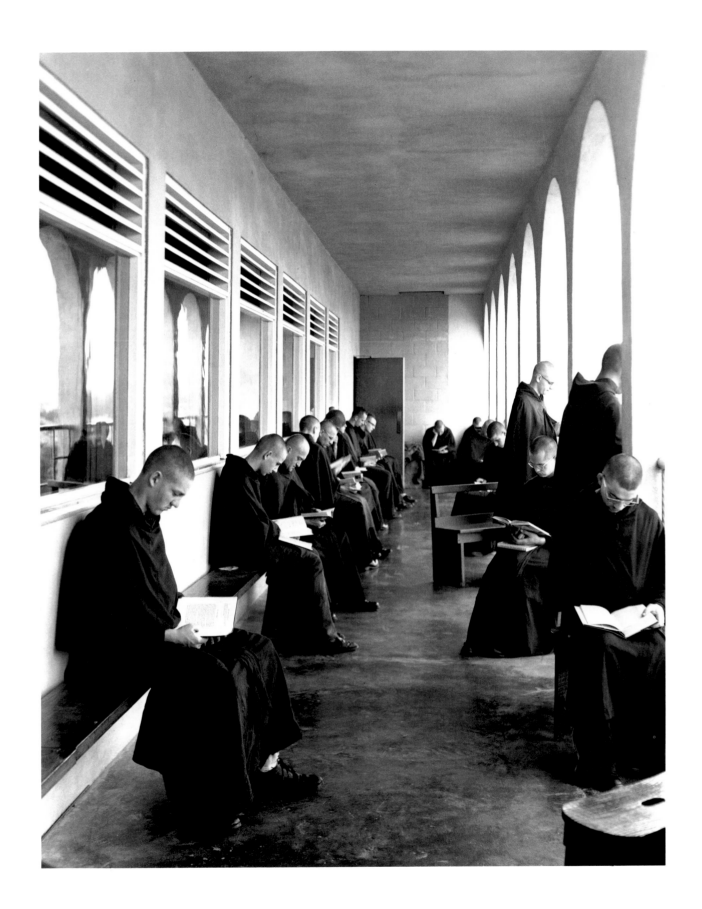

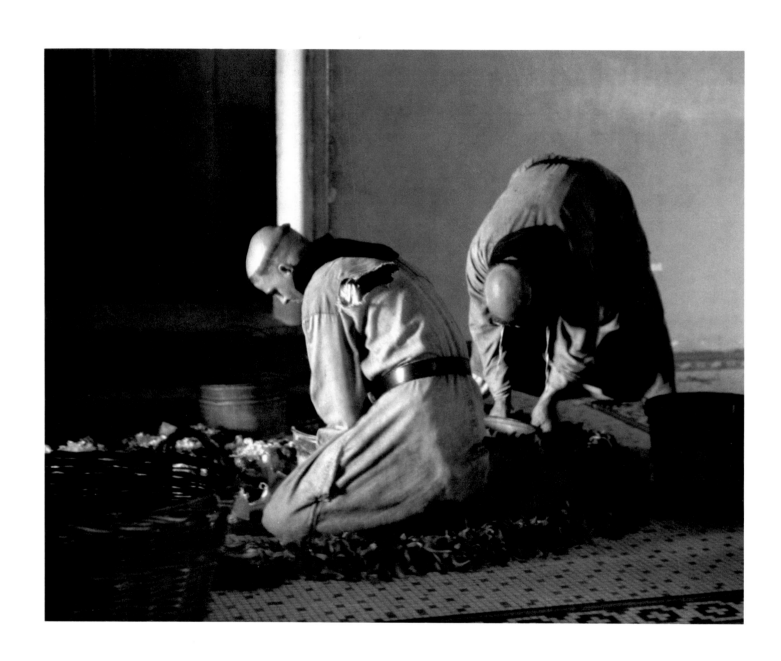

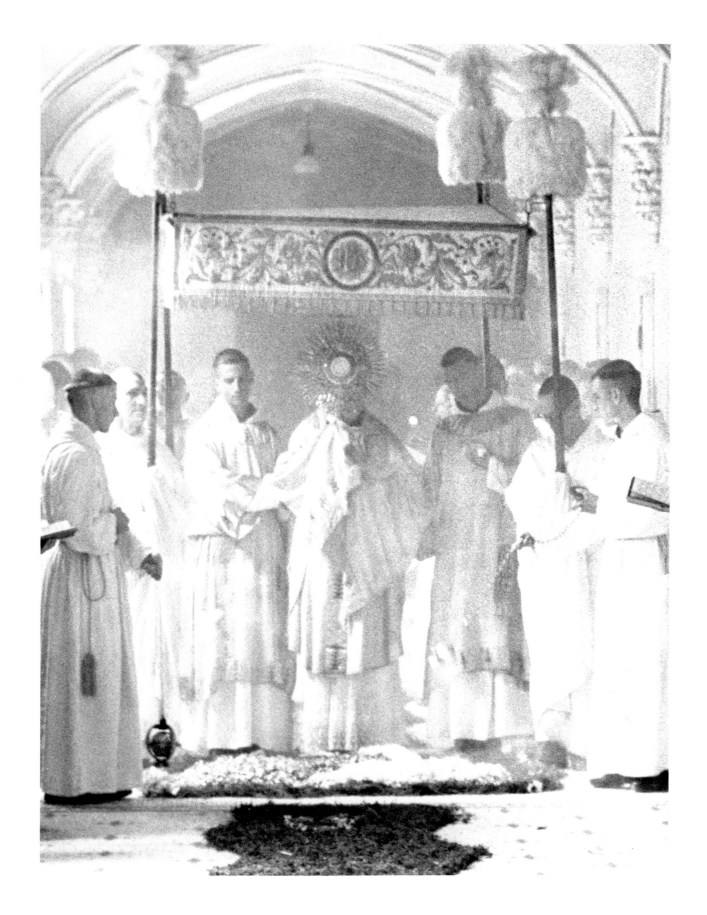

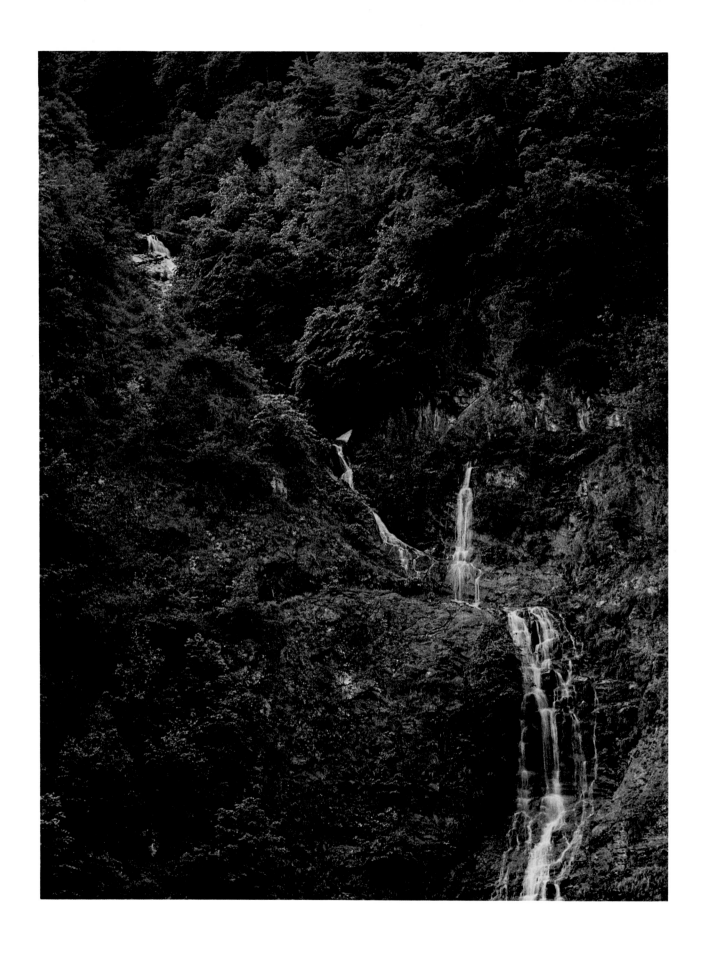

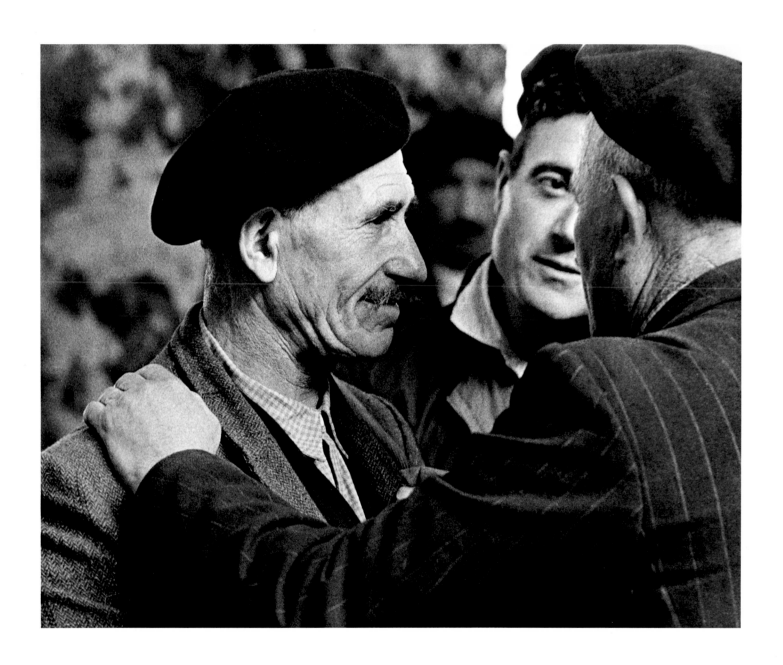

Lourdes once was a small village at the foot of the Pyrenees Mountains in southwestern France. Streams cascaded down the mountainsides into the River Gave below. Once a week farmers gathered in the marketplace to sell their produce.

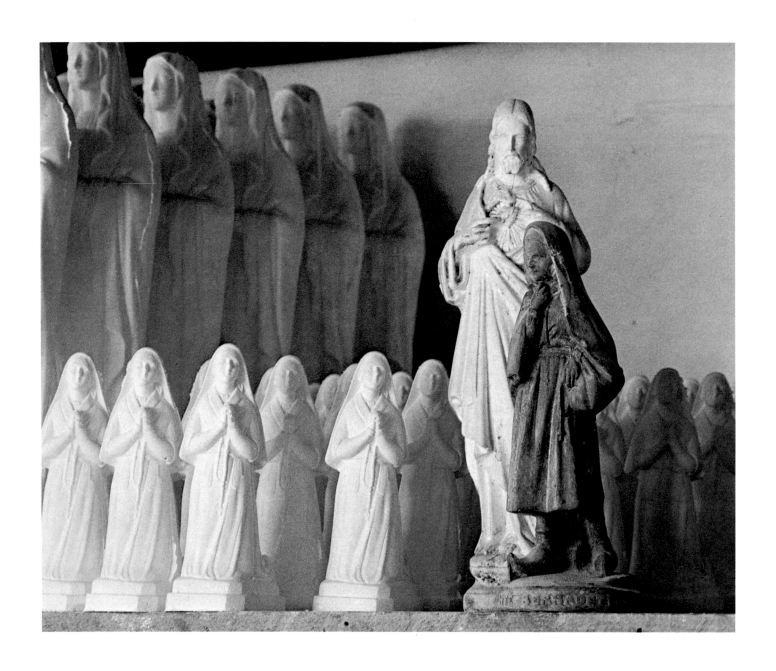

A young girl named Bernadette was walking by the river one day when she met and talked with the Virgin Mary. At first no one believed her story. Then there were cures. The blind saw.

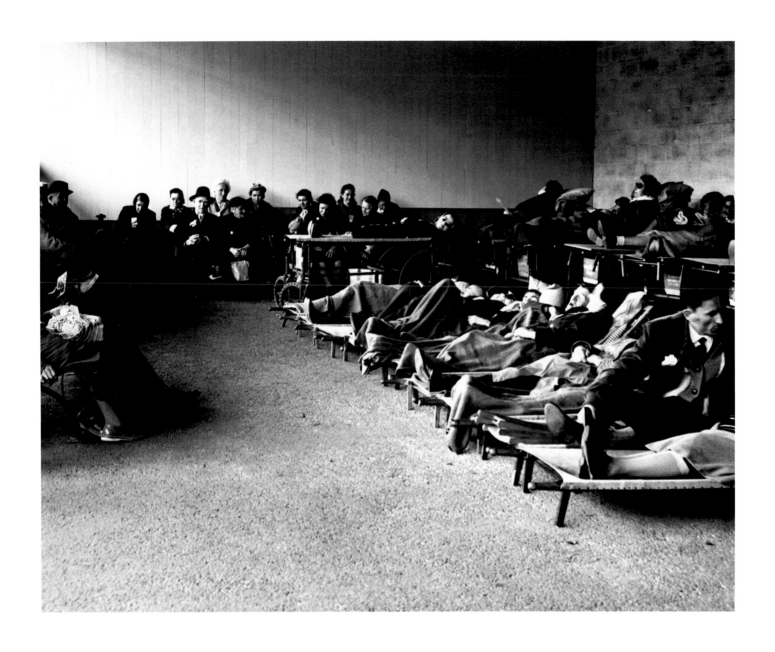

They built a cathederal in Mary's honor. They built hotels. Storekeepers came from all over France and set up shop. An enterprising family started a small factory to manufacture Madonnas. The rush was on.

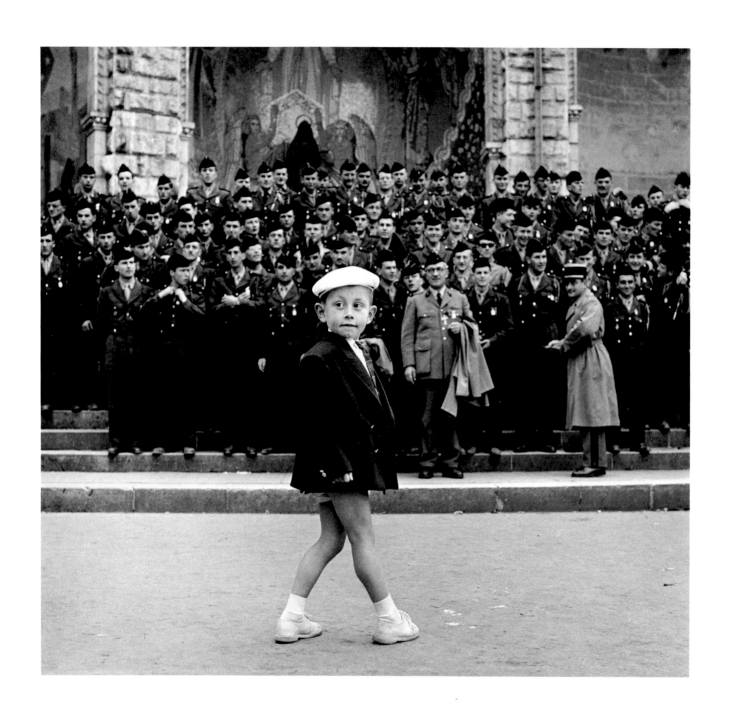

Sometimes it seemed more like a three-ring
circus than the peaceful little village Mary
once had visited.

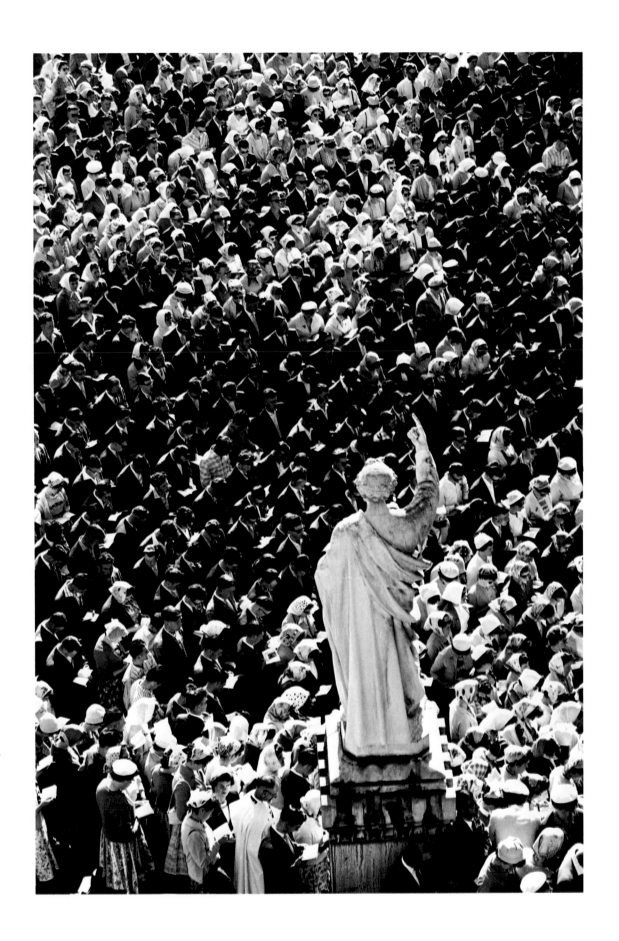

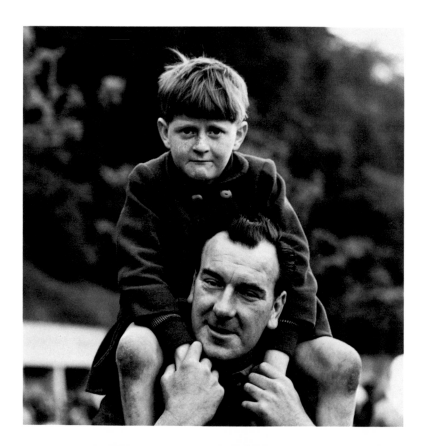

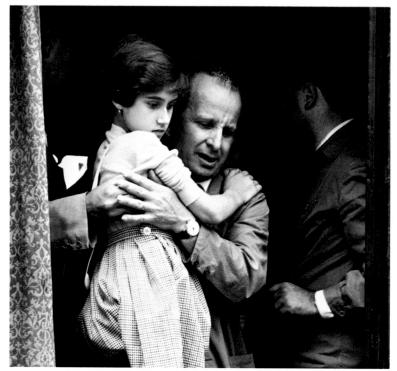

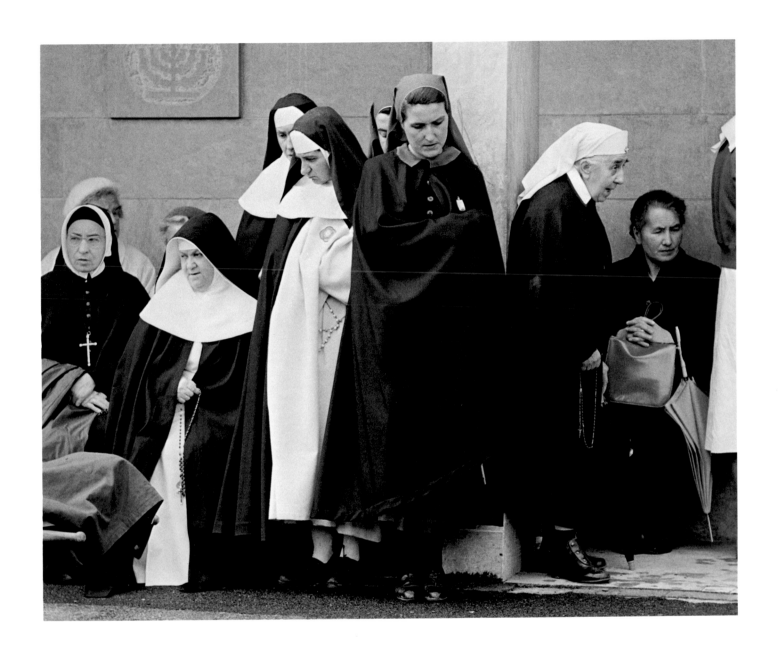

But faith is still in the hearts of the nurses
and stretcher-bearers who work there year
after year.

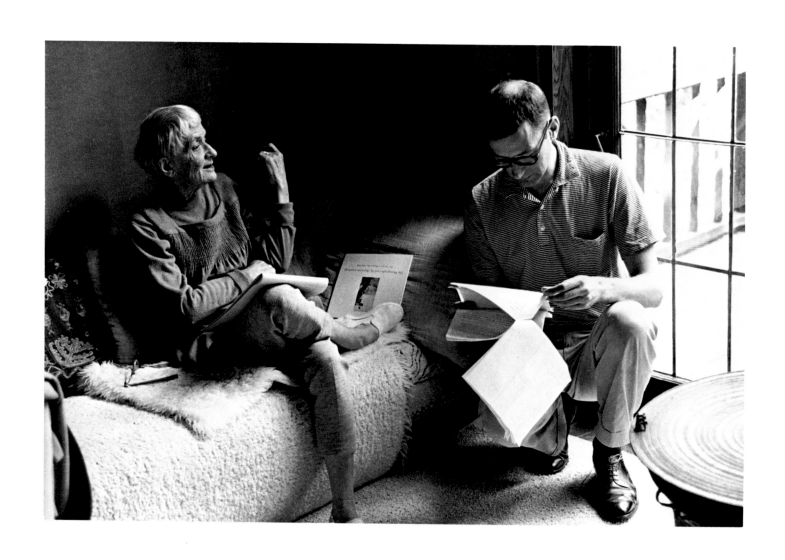

Dorothea Lange A call came one day in 1955 from Edward Steichen in New York City. He wanted me to collect photographs in the Los Angeles area that might be suitable for a show he was preparing called "The Family of Man." He had asked an old friend of his, Dorothea Lange, to do the same in San Francisco. I would do my best, I said, but I doubted my success, since most of my photographer friends in Los Angeles were very commercial.

Dorothea was one person I had always wanted to meet; her early pictures made for the Farm Security Administration during the Depression were some of the finest I had ever seen. I phoned her, told her my problem, and asked if she would come to Beverly Hills to give my friends a pep talk. She was as enthusiastic about Steichen's project as I was, and she accepted the invitation immediately. Then I called photographers who might have worthwhile pictures, told them Dorothea Lange was coming, and asked if they would come to my studio to meet her. Their negative enthusiasm was electrifying, so discouraging, in fact, that I nearly called the whole thing off.

When I went to the airport to meet Dorothea, I wondered if I would recognize her from her pictures. Several people came out of the plane first. Then a short, thin lady with a tanned, lined face and a gray-haired boyish bob appeared—that must be she. She was too far away then for me to see her eyes, but when she came closer, I thought, if the eyes are the windows of the soul, what a beautiful soul she has.

The trip from the airport to my house wasn't very long, but it was memorable. I left the airport in a state of complete nervous exhaustion. By the time we reached my house, Dorothea's charm and quiet manner had made me feel I'd known her forever.

We were talking about camera lenses and film sizes when she asked, "What camera do you like best, Shirley?" "I'm very fond of my Hasselblad," I said. "I like a larger-sized negative." "May I see it? I have heard a lot about it, but I have never seen one." When I handed it to her, she inspected it from every angle, then said, "It's a beautiful camera, but why don't you like people, Shirley?" I was rather taken aback by the question. "I do like people. Sometimes, I'm shy about taking their pictures. Why do you ask?" "Well, then, why stay so far away from them with a 150-mm. lens?"

We went to my studio at seven to await the arrival of my enthusiastic photographer friends, if any. I explained to Dorothea that I had asked a number of people, but how many would show up was a question. When eight o'clock came and went and no one appeared, I got pretty nervous. It didn't seem to worry Dorothea. Finally, the doorbell rang, and they started coming. Each one carried his portfolio and wore the expression of a young boy whose mother had caught him in the jam

Mother's Day

One gray day when it was trying to rain, I was walking up Lexington Avenue in New York. Halfway between 57th and 58th Streets there used to be a shop with no front that sold peacock feathers, fake flowers, wheat, and God-only-knows-what in the rear. The lights in the shop were much too bright, and the people rushing back and forth looked lost. But on a gray day it shone like a fake diamond in a pile of garbage. The shop was gone now; only a board fence remained, with some blackened rafters looking down at the crowds.

Then I crossed 59th Street into Bloomingdale country. It looked very much the same as it always had, but the spastic man selling comic books was missing.

I was about to cross Lexington Avenue at 60th Street to look at the puppies in the pet shop on the other side. A black man was standing, waiting for the light to change. He was holding a small—a very small—bunch of flowers in his hand. He had taken it out of a plastic bag and was inspecting the blossoms with great concentration. As I stood beside him he said, "Do you think they look faded?" The two or three crushed carnations he held were far from fresh, but I said, "I don't think so. They are beautiful, and the colors are so gay." He continued, as if he hadn't heard me. "I want to give them to my mother. She has been very good to me." He slipped the flowers back in the plastic bag and started across the street.

As he disappeared into the crowd, I was reminded of a mother I have known through the years. Our paths have crossed many times, in many places. I'm sure she loves his flowers and the thought that goes with them.

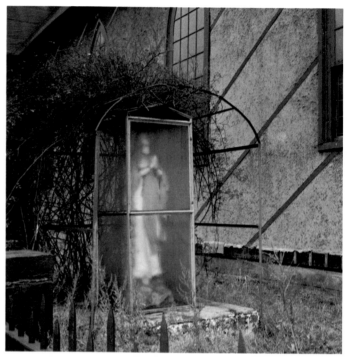

In a glass case, New Jersey

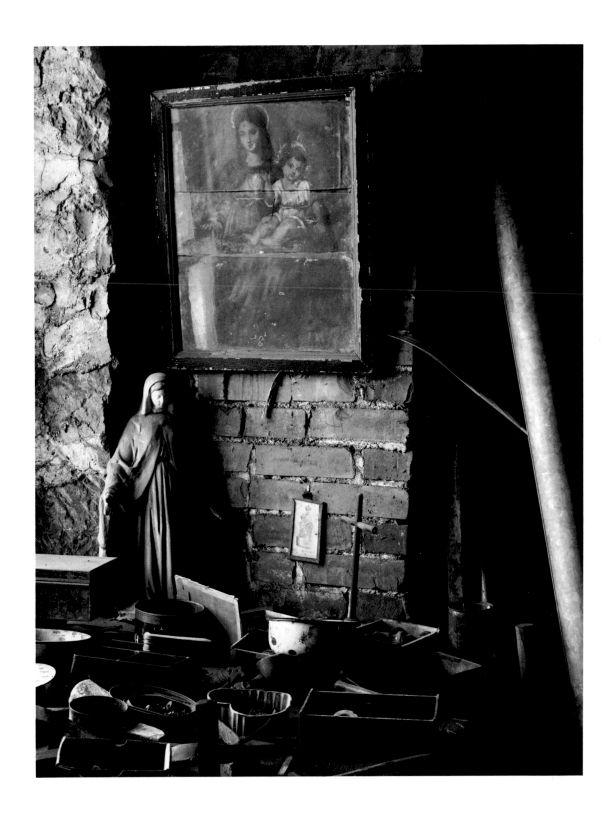

Gethsemani, a Trappist monastery, Kentucky

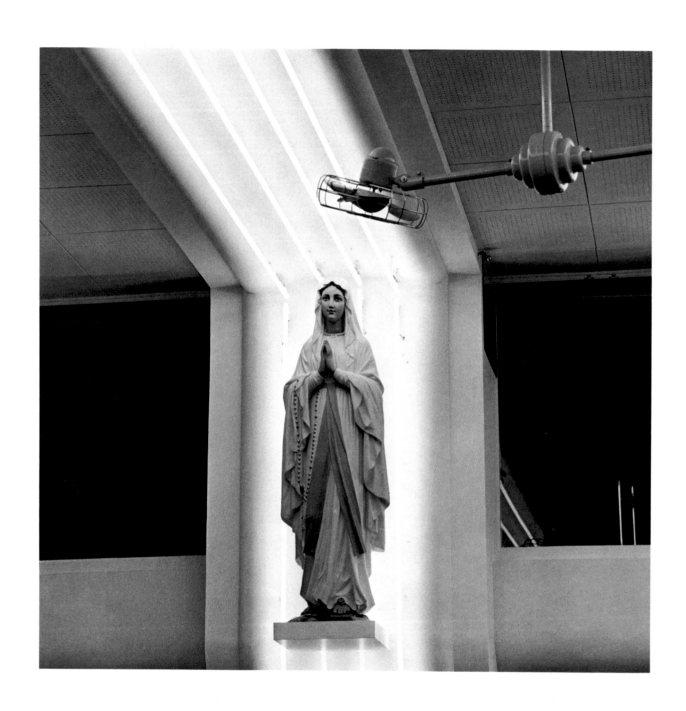

In a novelty shop, over a church door, and in a Madonna factory, Lourdes

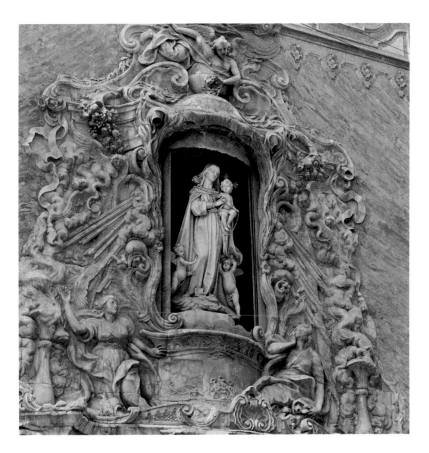

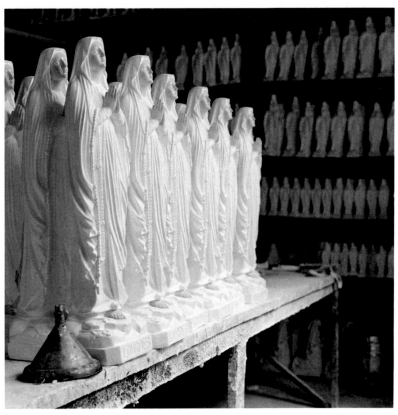

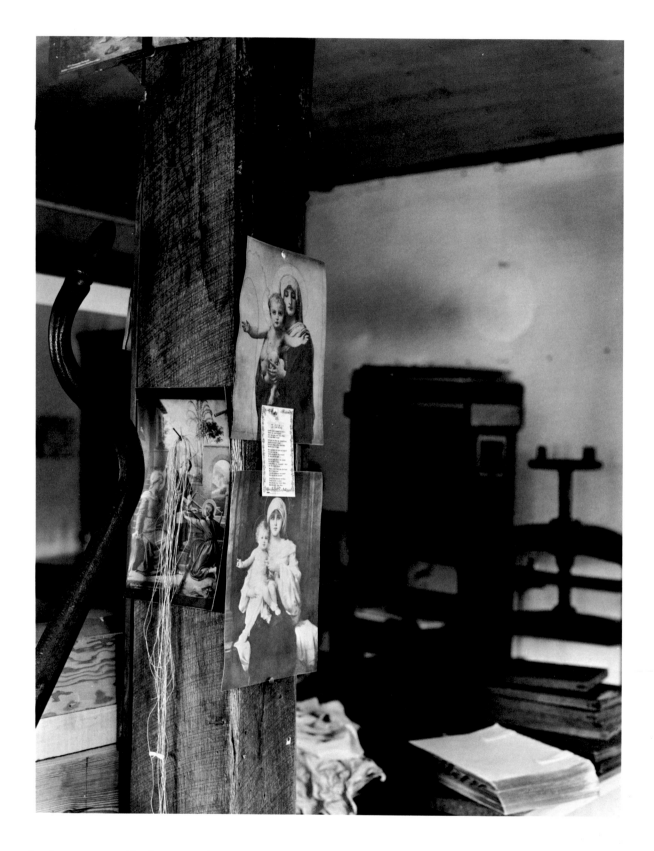

The printing room, Gethsemani

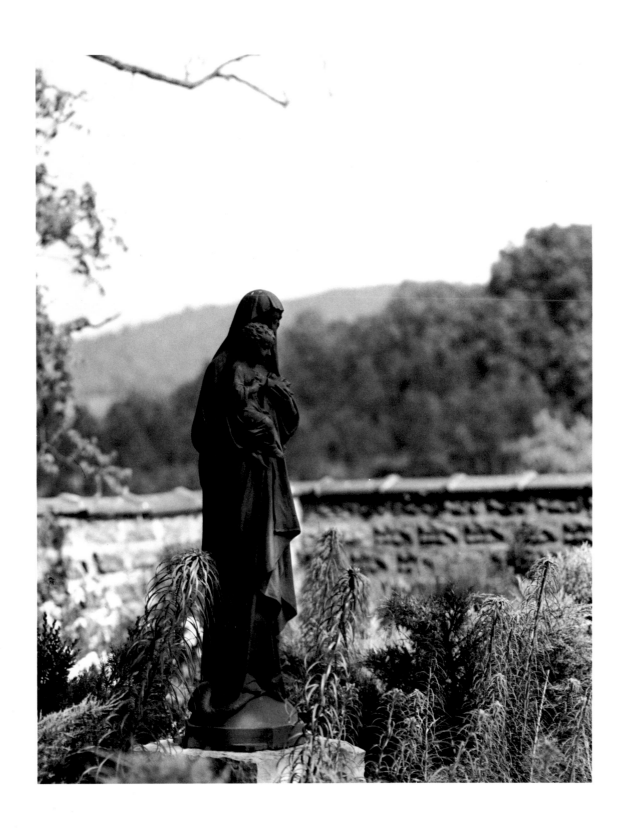

In Thomas Merton's garden

The Pueblo of Picuris

My wife and I had spent two summers at Lourdes. She worked in a hospital, and I took pictures for my book. It was a very rewarding experience for both of us.

Another summer was coming up, and we were trying to decide what to do. My wife knew some nuns in Santa Fe, New Mexico, who ran a hospital, and she thought she would like to work with them. "That's fine with me," I said. "I can photograph the Indians in the area." Little did she realize that a hospital in Santa Fe does not function like a hospital in Lourdes. Little did I realize that Indians do not wait in line to have their pictures taken.

My wife spent our first week in Santa Fe in the hospital pharmacy sorting bottles, while I was being turned down by the elders of two Indian reservations. Both of us were frustrated and discouraged. At Lourdes, my wife had washed and fed the sick: she laundered sheets and cleaned bedpans; she did everything, with no restrictions. At night, when she came back to the hotel, she was tired, but happy. It had all been worth it. I had found the same freedom at Lourdes: I photographed what I pleased, when I pleased, with no interference.

Now, after another frustrating day, we were having dinner in the hotel dining room when a motion-picture crew with actors, actresses, and lots of glamour arrived. They were going to make a pilot film for television. We all watched like a hungry bunch of teen-age autograph hunters as they trooped into the dining room. I was about to return to my soup when I noticed a familiar face, a unit manager I had known for many years in Hollywood. The following evening over cocktails I told him of my troubles with the Indians. Like all good unit managers he said, "Oh, that's easy. I have a friend." His friend turned out to be the United States government representative for Indian Affairs in the area.

When I went to see the man, I expected to find a rough and ready cowhand type, but I was mistaken: he turned out to be soft-spoken and kindly, more like a professor than a cowhand. He listened patiently to my story, then told me about the human side of Indians. His final remark summed it up: "You know, Mr. Burden, if the Indians had their way, they would build a hundred-foot wall around their reservations and never come out." As I was leaving dejectedly, he smiled and said, "There is a small group of Indians that are having trouble making ends meet. You might try them."

The next day I was on my way to the pueblo of Picuris. It was small, all right— very small. There were lots of beer cans, a church, and a few scattered houses. The elder I spoke with was so reserved that most of the conversation had to come from me. I explained what I wanted, suggested a sum of money I hoped would be acceptable (it was), and the deal was closed.

The following day I arrived without cameras. Dorothea Lange had once given me some very good advice: "Let people get used

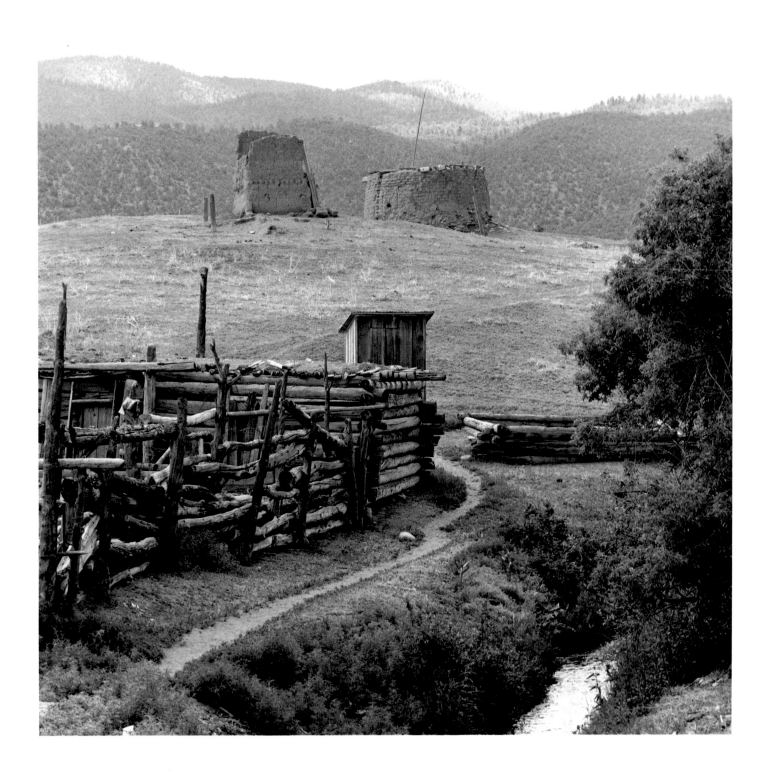

to you before you start taking pictures."
I spent two days trying to get acquainted.
Either there weren't any older people or they
were in hiding. As for the teen-agers and the
very young, I couldn't get rid of them. On
the third day, I brought out my camera and
took a few pictures, saying to myself, "I'll
really get organized tomorrow."

Tomorrow came, and I arrived raring to go,
but it wasn't to be. My friend the elder met
me with the news that a very important
personage in the tribe had died, and they
were going to have the funeral the following
day. Would I please leave and not return for
two days. Not being a *paparazzo*, I left.

Two days later when I returned, I started
taking pictures inside the church. It was
peaceful, and I was having a wonderful time
with my 4 x 5 view camera when I was
rudely interrupted by a very large Indian
female who had slipped in the front door
behind me. She was not in the least peaceful.
She asked in a very loud voice, almost a
shout, what I was doing there and who said
I could take pictures in her church. While
looking for the nearest exit in case of
emergency and at the same time explaining
to this battling mountain that I had made
arrangements to photograph the church, I
was trying to figure out what course to take.
Finally I decided when in doubt try flattery.
It worked. By the time I finished telling her
that the church figures were more beautiful
sculptures than Michelangelo's and that the
church must have been a model for St.
Peter's in Rome, I had her eating out of
my hand. When things calmed down, I
discovered that communication between her
and the elder was not of the best. She was in
charge of the church and he wasn't, and that
was that.

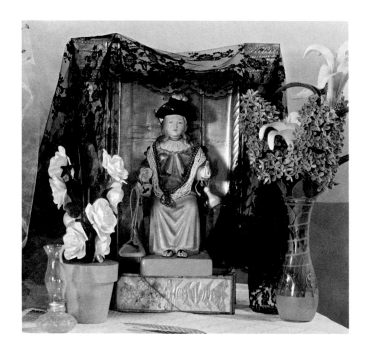

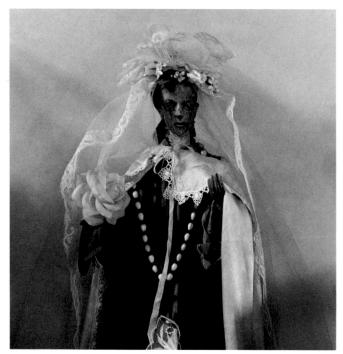

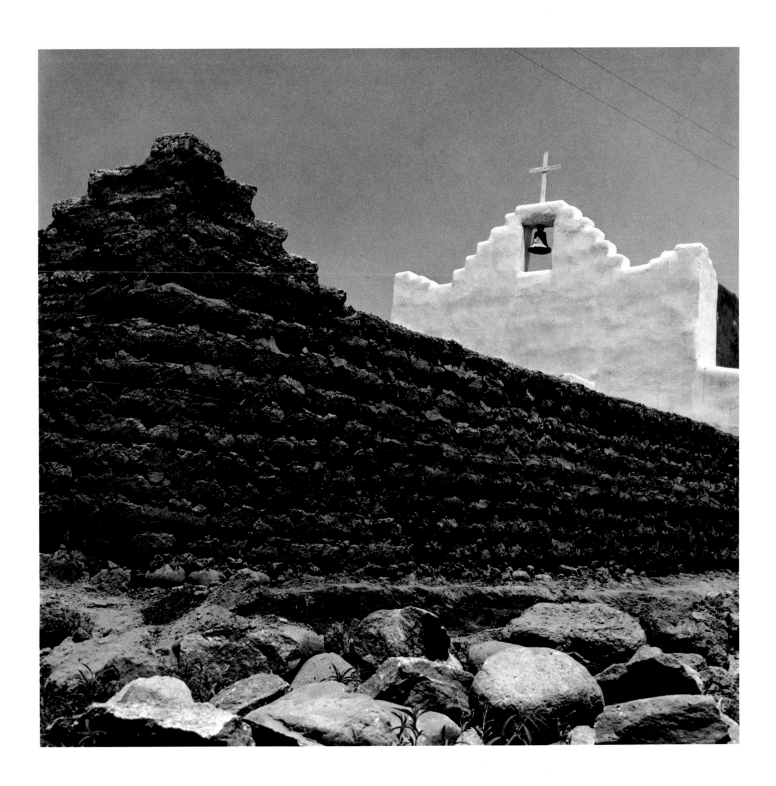

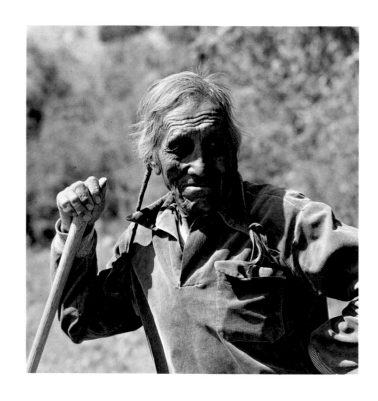

While taking pictures along a road leading out of town one day, I ran into a man who could have been the original model for the Indian head on the nickel. He lived in a log cabin, not more than ten by twelve feet. He was cultivating something that looked like dried grass, but turned out to be corn, in a garden not much larger than the front page of the daily newspaper. The garden was made up of rocks and dirt—not soil, dirt. On his front gate there was a sign that read, "It's great to be an American." I felt sorry for him at first—then I discovered that a lot of the older Indians wanted it that way.

Before I left Picuris for good I went into the church for one last look. There was a man there, and we started talking. "In the beginning," he said, "There were only Indians here. Then a Spanish priest came along and taught us Catholicism and made us leave our meeting place and build this church." He pointed to a hardly visible indentation in the wall at the right of the altar. "We killed him and put his skull in that hole." As he walked away he muttered, "It's still there."

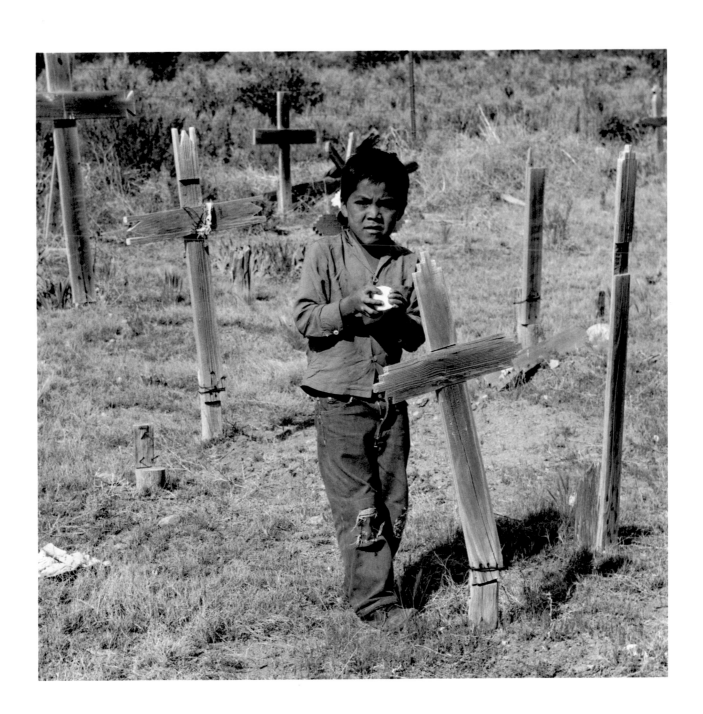

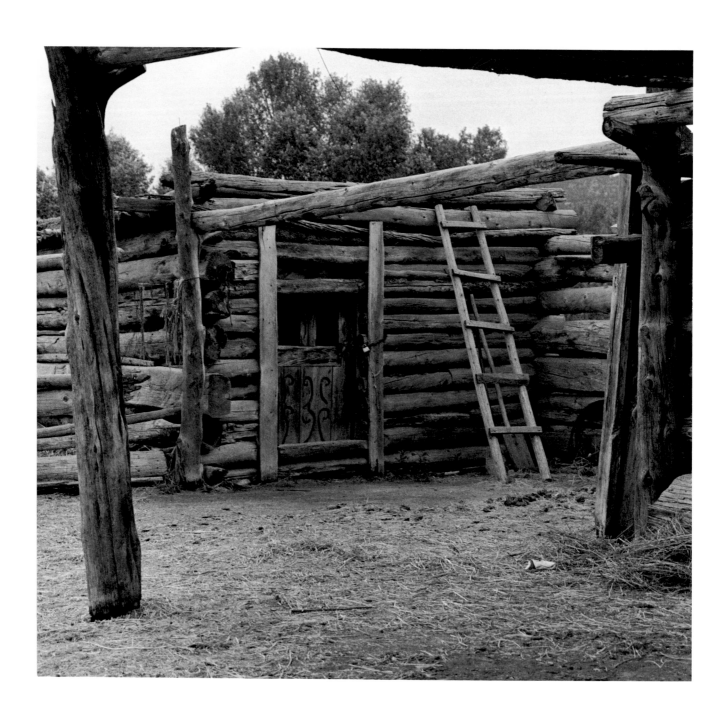

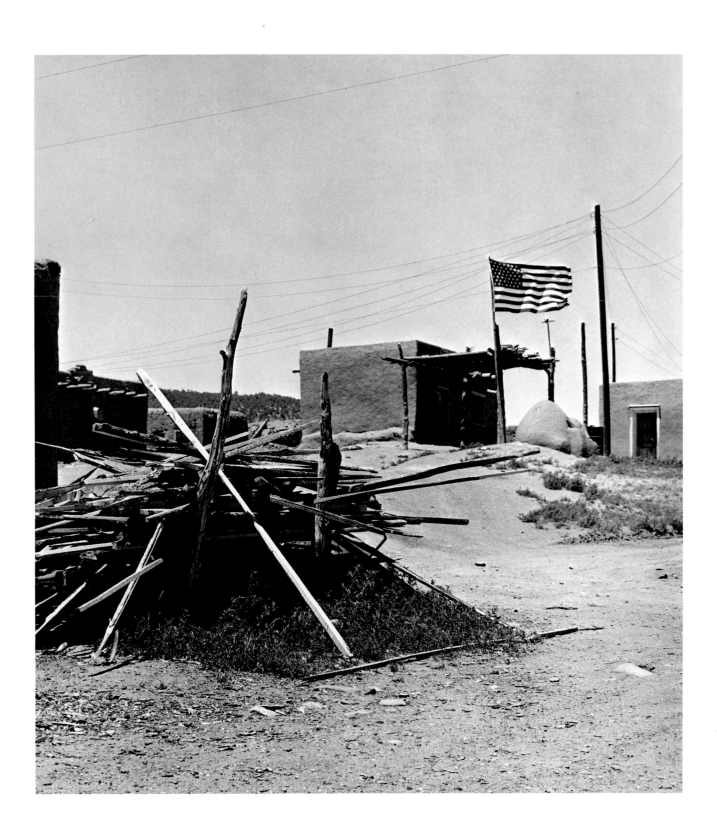

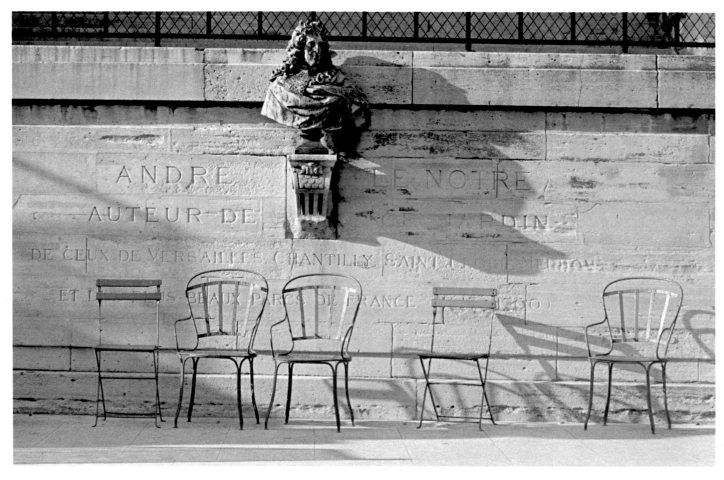

Watching the parade

Chairs

A chair, according to Webster's dictionary, is a seat, usually having four legs and a back, for one person. That may be all right for Webster, but I doubt that he ever saw a chair in a park in France. It has four legs and a back, but it has much, much more.

It has character.

It is a person rather than an object.

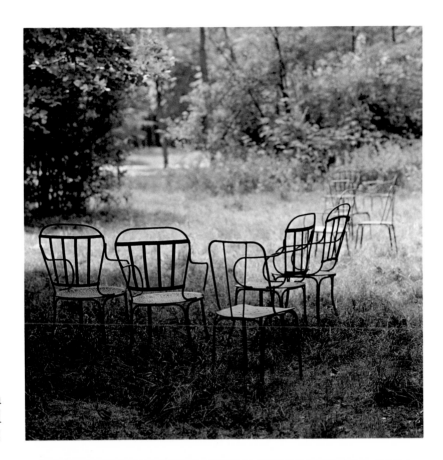

What a
wonderful
picnic!

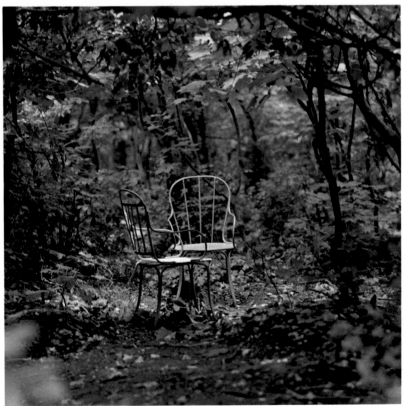

The secret
conference

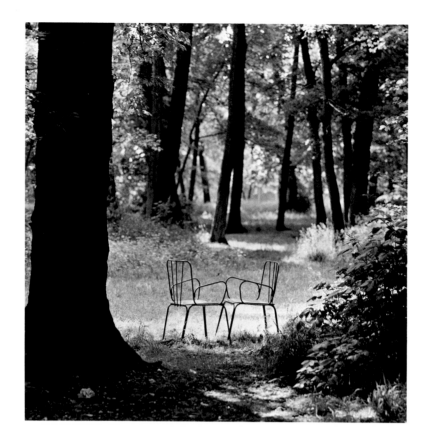

Lovers

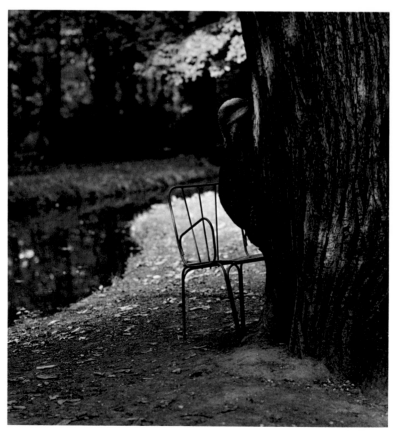

You're it!

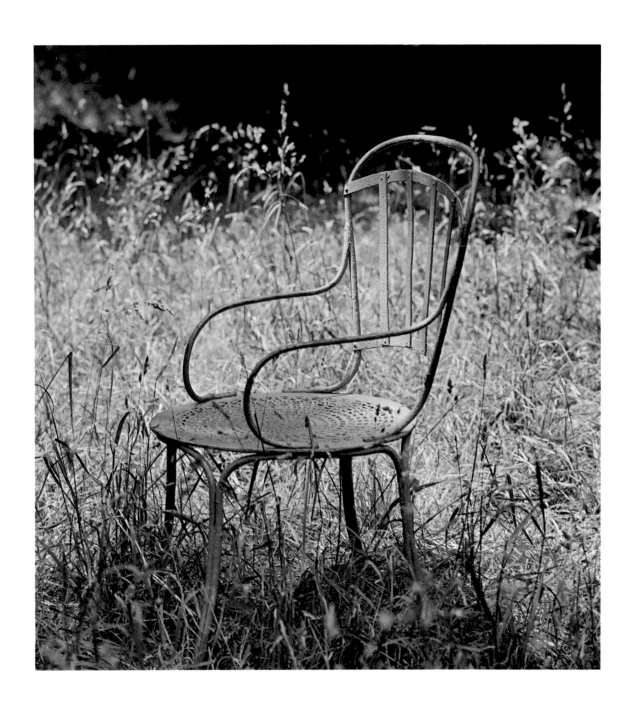

Come over where it's warm.

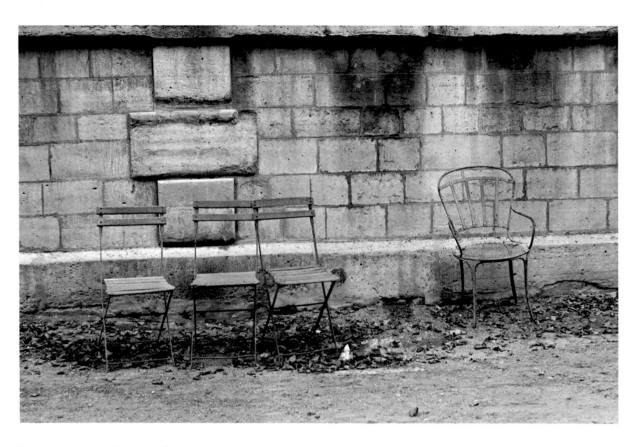

Pay no attention to her.
She's always like that.

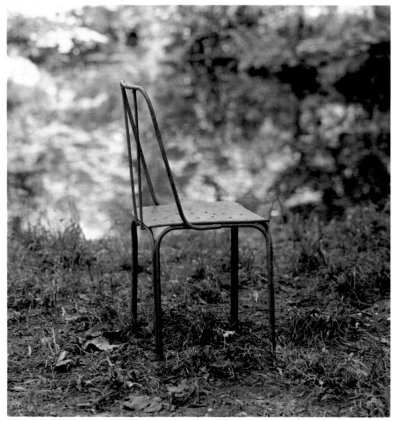

I feel so alone.

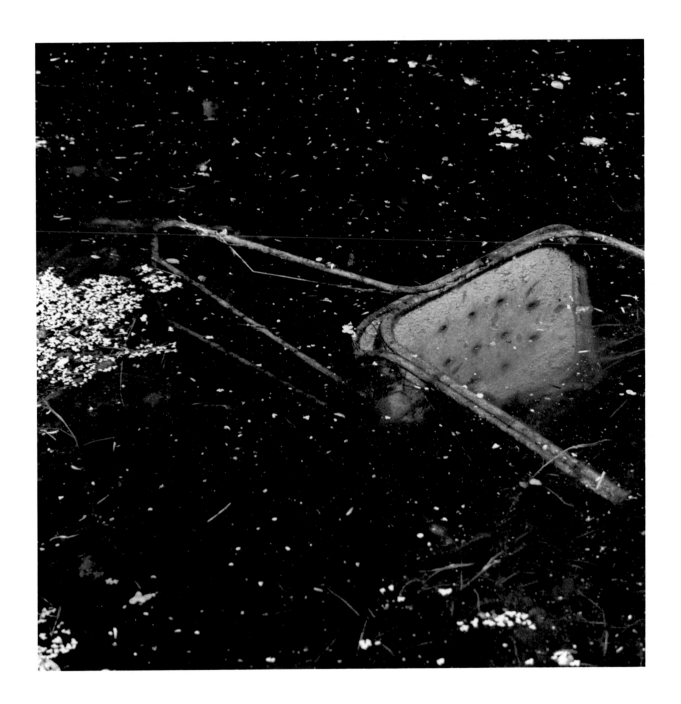

Forgive me. Good-bye.

Ireland

When His masterpiece was finished

He threw away His brushes

and destroyed the magnificent

shades of green still on His palette.

Then He said,

"Let it be as it is

for all eternity."

That's the way I found Ireland.
In other European countries,
I was aware of constant change as
I walked down the city streets.
In the country, trees and rivers and
flowers would vanish before my eyes.
Housing projects, factories, neon lights,
and gas stations would appear from
nowhere.
Not so in Ireland.
Life and death would come and go,
But even then, it had to blend with
the environment or it wouldn't exist.

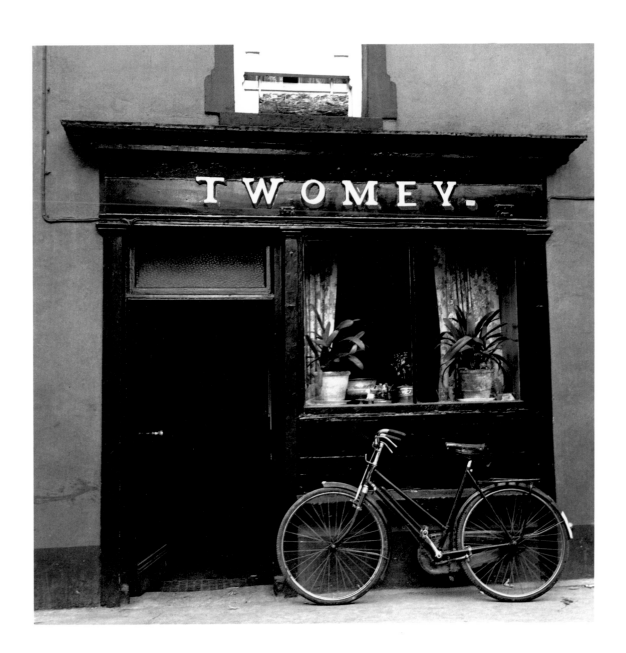

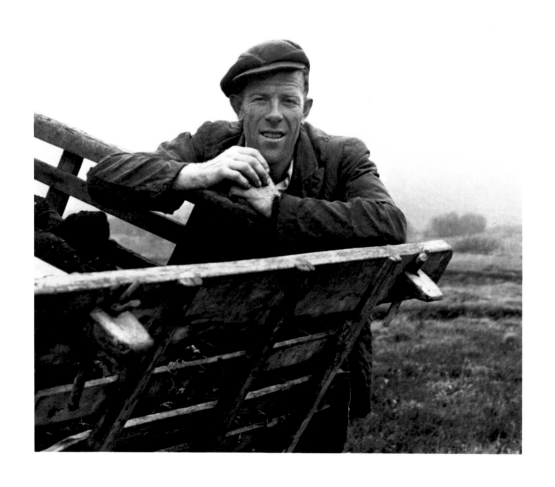

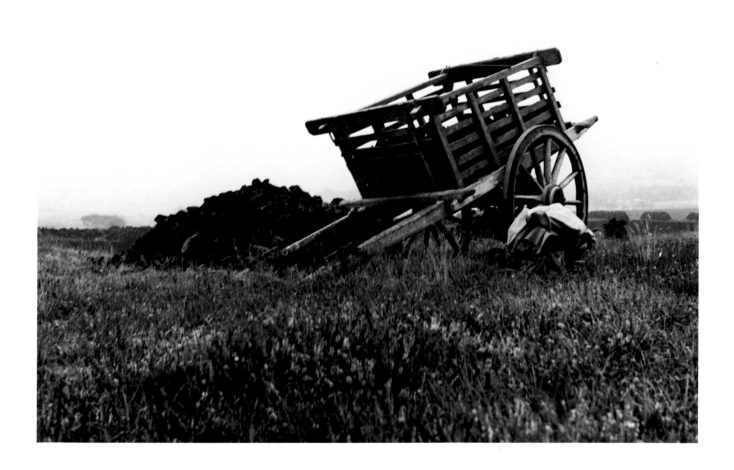

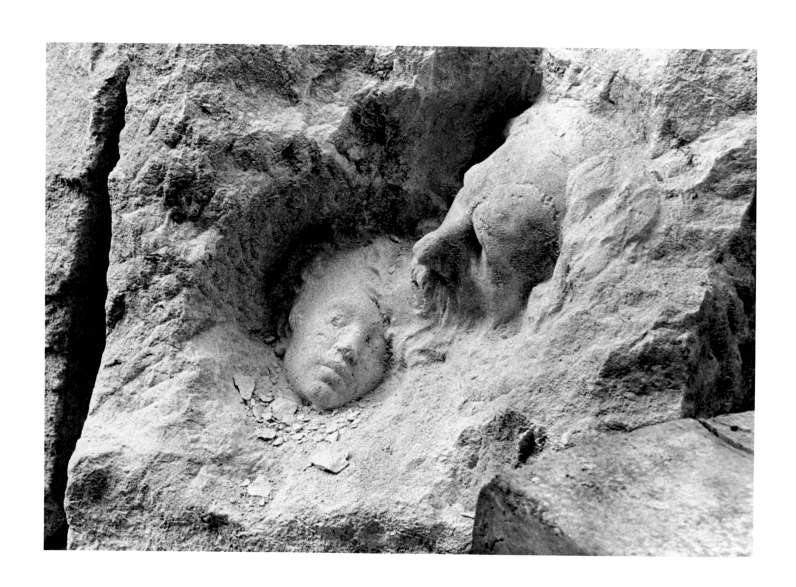

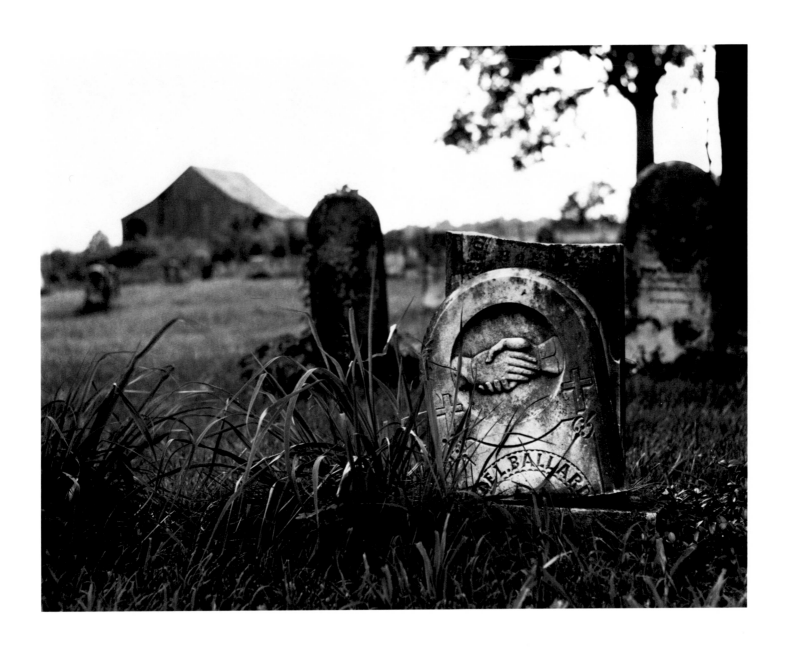

They were sad, lonely,
and sometimes very beautiful.
I never knew the people.
Then my wife died.

CHRONOLOGY

1908
Born December 9 in New York City, the son of William A. M. Burden and Florence Vanderbilt Burden.

1921
Finished high school at The Browning School in New York City.

1924
Courtland Smith, president of Pathé News, gave Burden his first job as a contact man for the newsreel company; he received instructions from the copy desk on what stories to cover and then made technical arrangements for the photographer and sound man.

1926
Joined his cousin Douglas Burden, a writer and explorer, to produce *The Silent Enemy*, a motion picture documenting the life of an Indian tribe in Ontario. The film was released by Paramount Pictures, and opened at the original Criterion Theater on Broadway in New York City. While cutting *The Silent Enemy* he met Jesse Lasky, head of production for Paramount in Hollywood; Walter Wanger, producer for Paramount; and Merian C. Cooper, a well-known explorer and close friend of Douglas Burden's.

1927
Offered a job as errand boy in the sound department at Paramount's Astoria, Queens, studios by Walter Wanger and accepted in order to learn more about sound recording, which was in its infancy.

1929
Met Edward Steichen, who became his mentor. Walked into Steichen's studio and asked for an appointment to have his photograph made as a present for his mother on his twenty-first birthday. Steichen agreed and charged him $100 for four poses. Unbeknown to Burden, Steichen's fees started at $1,000.

1929–1934
Went to Hollywood as assistant to Merian C. Cooper, who was then producing films for RKO. Was associate producer of several RKO films, including an untitled, never-completed movie on whaling, photographed off the Santa Barbara channel islands, and *She*, based on a book by Rider Haggart and starring Helen Gahagan Douglas, Randolph Scott, Helen Mack, and Nigel Bruce. Worked with Robert Benchley and Philip MacDonald as associate producer of films they were scripting.

1934
Married Flobelle Fairbanks, a niece of Douglas Fairbanks, Sr.

1936
First of two children, a daughter named Margaret Florence, born.

1941
A son, Shirley Carter Burden, Jr., born.

1942
Formed Tradefilms, Incorporated, a commercial motion picture company that produced training films during the Second World War for the United States Navy, the U.S. Office of Education, and Lockheed Aircraft.

1945
With the help of Les Novros, a Disney animator-director, formed Graphic Films to produce animation for Tradefilms' training films.

1946
Opened a studio with Todd Walker, a photographer for Tradefilms, specializing in still photography for advertising. Clients included *Arts and Architecture* magazine, *Architectural Forum* magazine, and Catalina bathing suits.

1950
Became interested in photography as a fine art, and from then on made pictures for himself only. Converted to Catholicism.

1952
Met Minor White and began an association with Aperture, Inc. that continues to the present.

1953
Photographed Ireland while vacationing with his wife and children.

1955
At the request of Edward Steichen, curator of photography at The Museum of Modern Art, collected photographs in the Los Angeles area for Steichen's "Family of Man" exhibition. A high point in his life occurred when he met Dorothea Lange, who was gathering prints for Steichen in the San Francisco area.

1956
Submitted photographs to Steichen who included them in his "Diogenes with a Camera IV" exhibition at The Museum of Modern Art. Photographed Ellis Island, the abandoned gateway to America for fourteen million immigrants. Grace Mayer, curator of prints and photographs at the Museum of the City of New York, exhibited the Ellis Island essay.

1958
Steichen presented Burden's essay on the Weehawken Ferry at The Museum of Modern Art.

1959
At Steichen's suggestion, photographed The Abbey of Our Lady of Gethsemani, a Trappist monastery near Louisville, Kentucky.

1960
God Is My Life, a book of photographs of The Abbey of Our Lady of Gethsemani with an introduction by Thomas Merton, author of the Seven Storey Mountain and a monk at Gethsemani, was published.

1961
Burden and his wife Flobelle met Winifred Feely, who was lecturing in the United States on Saint Bernadette and Lourdes, and they decided to travel to France to visit Lourdes. Flobelle worked in one of the hospitals and Burden photographed.

1962
Decided to do a book on Lourdes; returned to make more photographs, while Flobelle again worked in one of the hospitals.

1963
Sought a similar situation in the United States on their return; Flobelle worked in a hospital in New Mexico and Burden photographed the Picuris Indian reservation near Santa Fe, but arrangement was not as satisfying as the Lourdes experience. Photographed "I Wonder Why . . . ," the story of a black girl's encounters with racial prejudice. A book was published and a televised version appeared on the Red Skelton Show and the Tonight Show.

1965
Behold Thy Mother, a picture essay on Lourdes, was published. Asked by Dorothea Lange to help her and John Szarkowski choose photographs for a Lange retrospective at The Museum of Modern Art. (Lange died shortly after the opening.) Became a member of the museum's Photography Committee.

1969
After thirty-five years of marriage, Flobelle died. Burden traveled to Japan with a group of businessmen and their wives where he photographed extensively while sight-seeing.

1971
Married Julie V. Lyon.

1974
Joined the board of trustees of the Friends of Photography in Carmel, California.

1975
Appointed chairman of the Photography Committee at The Museum of Modern Art.

1976
Became a member of the advisory panel of the Santa Barbara Museum of Art.

1978
Began teaching a photography course, "Point of View," with Don Weir, a friend, at the Art Center College of Design in Pasadena, California.

Shirley Burden made the photographs in Presence in the 1950s and 1960s: "Patterns," 1965; "Weehawken," 1958; "Ellis Island," 1956; "What Is Faith?," 1957; "Dorothea Lange," 1965; "Mother's Day," 1956; "The Pueblo of Picuris," 1962; "Chairs," 1960; "Ireland," 1953; "Death," 1960; and "The Tail of the Squirrel," 1976.

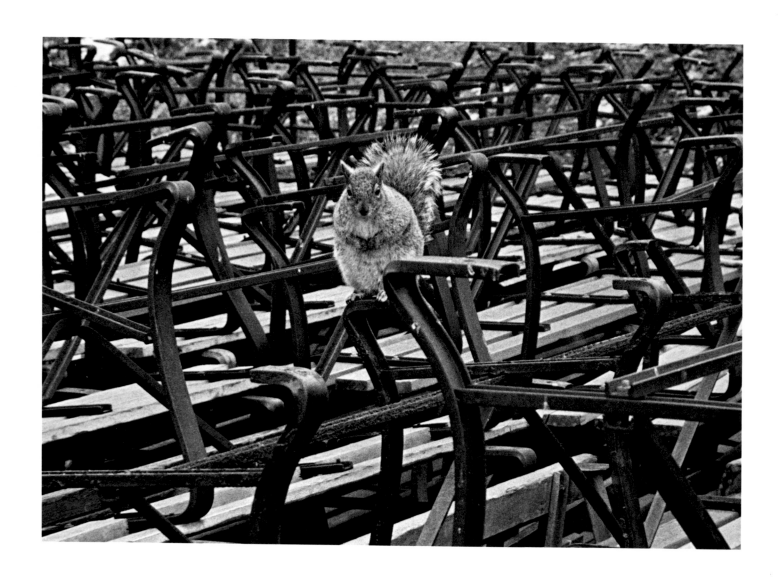

The Tail of the Squirrel.

The other day I met a squirrel in Central
Park.
He had black, beady eyes,
a gray fur coat with a few white hairs in it,
and a very bushy tail.
They say that when a squirrel has a bushy
tail it's going to be a cold winter.
He was collecting nuts, and
I offered him one I had picked up,
which he quickly grabbed.
Sitting back on his hind legs, he
turned the nut over in his paws,
inspected it carefully,
then put it in his mouth,
jumped to the ground,
and ran to a patch of grass nearby.
There he dug a hole and
put the nut in it,
Busily, he replaced the dirt,
patting it with his paws
until the hole disappeared.
Then he ran off in search of other donors.
All this activity impressed me very much—
so much so, in fact, that
I repeated it to my brother, who has a very
practical turn of mind.
He listened as I told him of my meeting
and then said, "Oh."
I thought that was that.
Some time later he said, "You remember the
squirrel you met in the park? Well, I have
been doing a little research on him, and I find
from unimpeachable sources he never knows
where he buries his nuts."
My dream was shattered. I was sure he was
storing them for that cold winter his bushy
tail predicted.

Come to think of it, I have great difficulty
these days, finding the things I put away
carefully for future reference.
Perhaps my squirrel friend and I have
something in common.